M.C. ESCHER
KALEIDOCYCLES

Doris Schattschneider and Wallace Walker

Tarquin Publications

© 1978 By Doris Schattschneider and Wallace Walker
First edition October 1977
Second printed June 1978

Special edition © 1982 Tarquin Publications
ISBN 0 906212 28 6
Reprinted 1985, 1989, 1991
Tarquin Publications, Stradbroke, Diss, Norfolk IP21 5JP, England
Printed by the Five Castles Press Limited, Ipswich

Contents

Acknowledgments

The preparation of drawings and print mechanicals for the models in this collection was directed by Wallace Walker. The adaptation of Escher's periodic designs to a form suitable for continuously covering the geometric solids and kaleidocycles was carried out by Robin McGrath, Robert McKee, Victoria Vebell, and Wallace Walker.

The authors express appreciation to the M. C. Escher Foundation, Haags Gemeentemuseum, The Hague, Netherlands, The National Gallery of Art, Washington, D.C., and Mr. C. V. S. Roosevelt for their cooperation in providing illustrative material for this book.

Sources of illustrations:
M. C. Escher Foundation—Figures 15, 16, 17, 18, 19, 20, 24a, 30a, 31c, 32, 33, 36a, 38, 41, 42, 45, 46, 50, 51, 53, 55.
National Gallery of Art, gift of Mr. C. V. S. Roosevelt—Figures 1, 3, 5, 14, 21, 22, 31b, 44, 47, 54.
National Gallery of Art, Rosenwald Collection—Figure 23.
C. V. S. Roosevelt—Figures 31a, 34, 48, 52.

Note on captions: M. C. Escher did not assign titles to his colored drawings of periodic designs, but numbered them consecutively and dated them. In a few cases ("Three Elements," "Shells and Starfish," and "Heaven and Hell") names came to be associated with the drawings. In the text, we identify each periodic drawing by Escher's number and date (month and year) and give a descriptive name.

M. C. ESCHER KALEIDOCYCLES
by
Doris Schattschneider
and
Wallace Walker

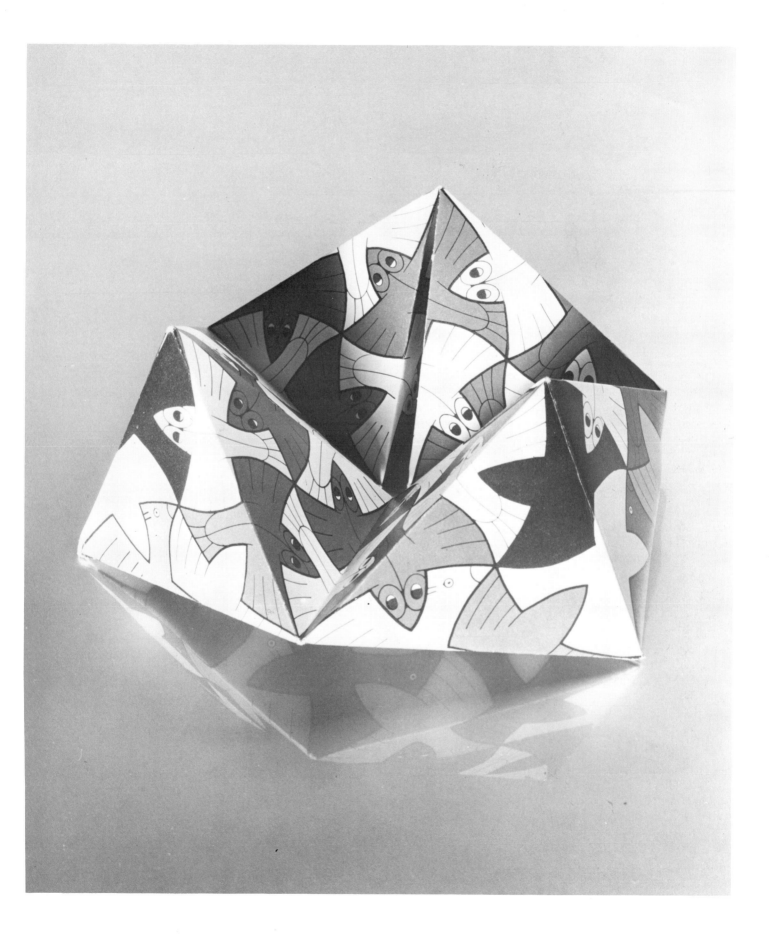

In Three Dimensions:
Extensions of M.C. Escher's Art

by Doris Schattschneider

Everyone loves surprises. There are two types of surprises — the one is a happy accident or coincidence; the other is meticulously planned, perhaps cunningly disguised to appear natural, and brings double pleasure. It is often hard to say who has greater delight — the person who is surprised or the one who devised the magic.

The Dutch artist M.C. Escher (1898-1972) was an ingenious planner of many surprises of the second kind. His graphic art fairly bursts with cunningly planned visual surprises. At first glance much of his work appears natural, yet, at second glance, the seemingly plausible is seen to be impossible and the viewer is drawn to look again and again as he discovers with delight the hidden surprises the work contains.

How did Escher do it? He was a genius of imagination, a skilled graphic craftsman, but the key to many of his surprising effects is mathematics. Not the mathematics of numbers and equations that most of us envision; but geometry in all aspects, both classical and modern. Escher could imagine the fantastic effects he wished to express graphically, but a necessary tool to capture these effects was mathematics. For this reason, he read technical works and corresponded with mathematicians and crystallographers — all the while disclaiming his ability to understand mathematics and yet visually expressing his understanding of the vital principles he needed.

The kaleidoscopically decorated geometric forms in this collection are a continuation and extension of Escher's own work. Covered with adaptations of Escher's designs, they embody many of the themes dominant in his prints and are related to his own explorations of three-dimensional expression. In light of his work, it is not surprising that these creations required the collaboration of a mathematician and a graphic designer.

Your involvement is required also! A casual glance cannot reveal the surprises to be discovered in Escher's prints. So, too, the secrets to be discovered in our models are only revealed by your creating the forms, examining them, and, yes, playing with them! Each geometric model begins as a flat design; *you* bring it to "life," providing the transition from its two-dimensional to its three-dimensional state. Once brought to life, the models provide many surprises for both hand and eye — the two-dimensional pattern gives few clues as to what you will see and feel when it takes shape in three dimensions.

Before assembling the models, you are invited to explore their various aspects: form, decoration, coloration, and relation to Escher's own work. The journey will touch on many of the paths explored by Escher as well as some newly discovered.

Figure 1. *Stars*, wood engraving, 1948. National Gallery of Art, Washington, D.C. Gift of Mr. C.V.S. Roosevelt.

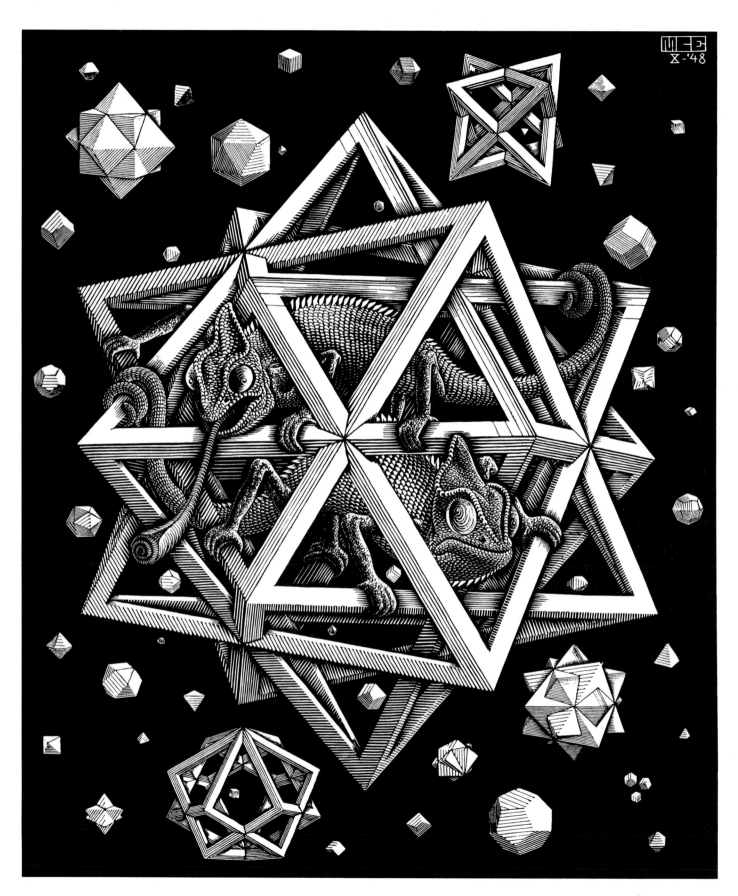

The "stars" which hang in Escher's black outer space (Figure 1) are geometric forms with the symmetry of faceted jewels. Surrounded by geometric models in his studio, Escher readily admitted his awe of these forms and included them in many of his prints.

Admired and exalted from earliest times, the Platonic solids (Figure 2) are the most perfectly symmetric of all solids. How perfect? Each form is faceted with copies of a single regular polygon — all sides and all angles of all faces are equal. In addition, every corner (vertex) of the solid is the same — the same number of faces meet there, and the angle at which adjoining faces are inclined to each other is always the same. Mathematicians call these *regular solids.* In each of them, every possible requirement that aspects of the form be alike (congruent) is fulfilled. These requirements are so severe that only five forms can meet them all.

Their names come from the original Greek and tell us how many faces they possess. Three are faceted with equilateral triangles: *tetrahedron, octahedron, icosahedron.* The *cube,* faceted with squares at right angles to each other, is the most familiar form of all. Its name comes from the Greek word for "dice" — *cubos.* The *dodecahedron* is faceted with pentagons; it is perhaps the most admired since it is the least obvious of the solids to imagine. Escher's little dragon, at the pinnacle of his fanciful journey, gives a snort of power atop a dodecahedron in the print *Reptiles* (Figure 3).

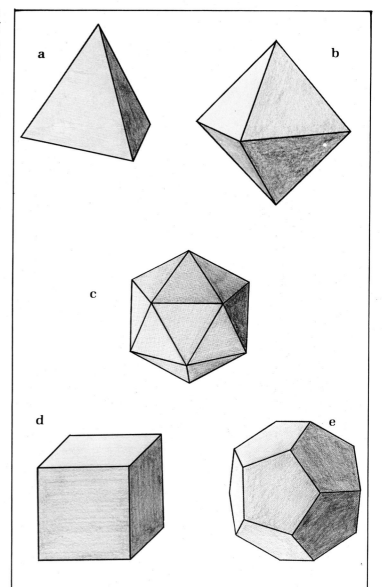

Figure 2. The five Platonic solids. (a) Tetrahedron: four sides. (b) Octahedron: eight sides. (c) Icosahedron: twenty sides. (d) Cube: six sides. (e) Dodecahedron: twelve sides.

Figure 3. *Reptiles*, lithograph, 1943. National Gallery of Art, Washington, D.C. Gift of Mr. C.V.S. Roosevelt.

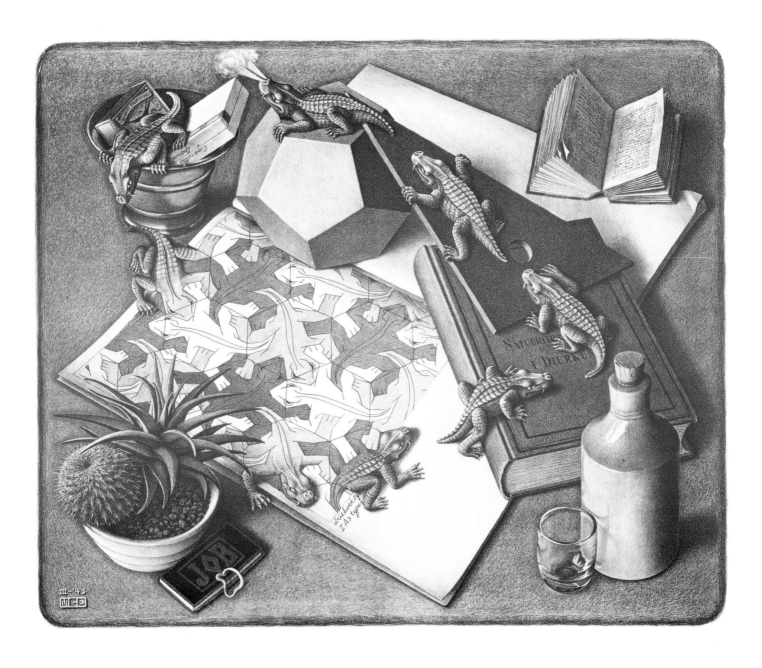

If just one of the requirements for a solid to be regular is removed, a large collection of other highly symmetric forms can be discovered. The Archimedean (or semi-regular) solids allow two or more types of regular polygons as faces but fulfill all other requirements of regular solids. Thus all sides of all faces are equal; every corner of the solid is the same (surrounded in the same manner by the faces which meet there). There are thirteen semi-regular solids; we have included just one in our collection.

The cuboctahedron (cube + octahedron) has as its faces six squares and eight equilateral triangles (Figure 4). Each of its twelve vertices (corners) is surrounded by two triangles and two squares arranged so that the two squares separate the two triangles. The name of this solid suggests its derivation — it can arise either by chopping off corners of a cube or by chopping off corners of an octahedron. It can also arise as the solid which is the intersection of an octahedron with a cube as shown in Escher's print *Crystal* (Figure 5).

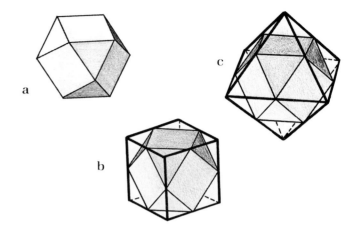

Figure 4. (a) The cuboctahedron can be obtained from (b) a cube or (c) an octahedron by slicing off their corners (always cutting through midpoints of the edges which meet at a corner). If all protruding corners are sliced off Escher's *Crystal* (Figure 5), which is an interlocked cube and octahedron, the cuboctahedron is the resulting solid.

Figure 5. *Crystal*, mezzotint, 1947. National Gallery of Art, Washington, D.C. Gift of Mr. C.V.S. Roosevelt.

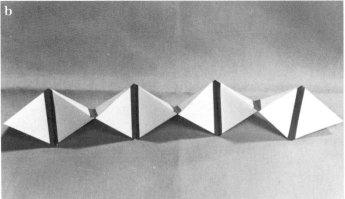

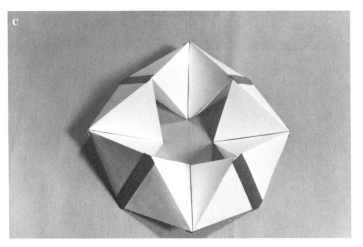

Figure 6. Linking together several tetrahedra along their edges produces a ring of tetrahedra. The kaleidocycles can arise in this way.

A kaleidocycle is a three-dimensional ring made from a chain of tetrahedra. Begin with several tetrahedra, all exactly alike (Figure 6a). Hinge together two of these along an edge of each tetrahedron to begin a chain of tetrahedra, each one linked to an adjoining one along an edge (Figure 6b). When the chain of tetrahedra is long enough, the ends can be brought together to form a closed circle (Figure 6c). The hinges of the chain allow the ring to be turned through its center in a continuous motion.

Contrary to the impression given by most textbooks, the discovery of new forms and new ideas is rarely the product of a predictable evolution. An unexpected discovery is made, and much later, the new knowledge is placed in its "natural" position with respect to the larger body of knowledge of which it becomes a part. So, too, with the discovery of kaleidocycles. Although they naturally evolve in the manner described above, it was an extremely different analysis that led to their discovery.

First came the form IsoAxis® (U. S. Patent No. 3302321), invented by Wallace Walker, a graphic designer. Walker created IsoAxis® as a solution to a design problem in 1958 while a student at Cranbrook Academy of Art in Michigan. In two dimensions, IsoAxis® consists of a grid of sixty connected isosceles right triangles (Figure 7a). In this two-dimensional state, the pattern gives no hint of its surprising three-dimensional form. When folded on the grid lines and assembled into a three-dimensional ring, IsoAxis® assumes a bold symmetrical shape (Figure 7b). Finally, astonishingly, the form can be rotated through its center, at each turn transforming its appearance (Figures 7c and d). After five rotations, it resumes its first shape and the cycle of transformation can begin again.

A mathematical mind is quick to ask: What relation does the two-dimensional grid have to the three-dimensional form it produces? What happens if the grid is altered? Investigation of these questions by the author, a mathematician, led to the discovery of an infinite family of three-dimensional forms. The kaleidocycles in our collection are members of this family.

The grid of lines which forms the flat pattern of IsoAxis® is like an adjustable wooden gate or a hatrack which can be stretched or collapsed. Stretching or collapsing the IsoAxis® grid produces new flat patterns which can be folded up in the same manner as Iso-Axis® to form a ring faceted with triangles. Surprisingly, these new forms also rotate through the center of the ring. "Kaleidocycles" seems an appropriate name for these highly symmetric forms which turn cartwheels in an endless cycle (Greek: *kalós* [beautiful] + *eîdos* [form] + *kŷklos* [ring]).

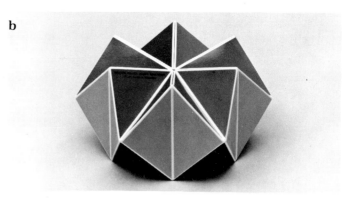

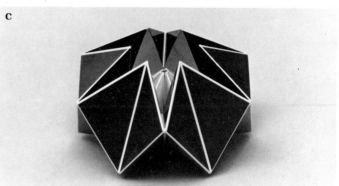

a

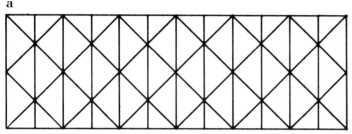

Figure 7. IsoAxis® begins as a flat grid of isosceles triangles. It folds into the solid shown—and then "blooms" as its facets are pushed through the center hole of the ring. Photo: Terry McGinnis.

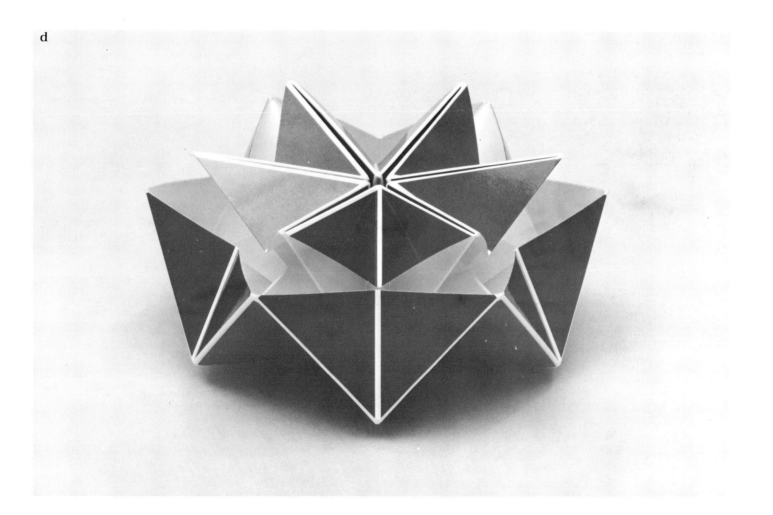

The kaleidocycles created when the IsoAxis® grid is collapsed look like many-faceted folded-paper Danish lampshades. They have great flexibility, and seem to "bloom" like flowers when rotated; however, they are difficult to handle because of the large number of facets.

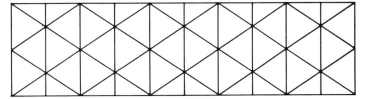

Figure 8. A grid produced by stretching the IsoAxis® pattern.

When the IsoAxis® grid is stretched (Figure 8), all of the angles in the triangles formed are less than right angles. When this pattern is folded into three-dimensional form, it forms a ring of linked tetrahedra! By moving the small triangles at the top of the grid to join

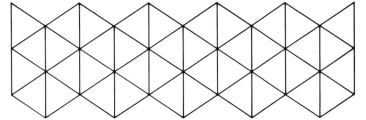

Figure 9. This grid has all triangles equal; when folded and assembled, it produces the same ring of tetrahedra as the grid shown in Figure 8.

those at the bottom, yet another new grid (Figure 9) is formed which produces the same three-dimensional form. Each vertical "strip" of four equal triangles folds into a single tetrahedron, and the vertical lines on the flat pattern become the hinges of the linked chain when it is folded. By adjusting the amount of stretch of the grid, or adding more triangles, an infinite variety of rings of linked tetrahedra can be created.

More questions were asked: How few tetrahedra can form a closed ring? How small can the hole in the center of the ring be made? Experimentation, guided by facts of plane and solid Euclidean geometry, answered these questions. In order to form a closed ring, at least six tetrahedra are required. The "hole" in the center can be made (theoretically, at least) as small as a point and still the tetrahedra will tumble through it. Finally, rules were worked out for the construction of triangles which produce a ring having a point as center hole.

Now many beautiful kaleidocycles could be constructed. The first two in the family of forms having a point as a center hole have familiar outlines when viewed from above (Figures 10a and b). The kaleidocycle whose ring is formed by six tetrahedra has the outline of a regular hexagon (Figure 10a), while the ring of eight tetrahedra has the outline of a square (Figure 10b). As the number of tetrahedra in a kaleidocycle is increased, these outlines become like many-petaled flowers or stars (Figure 11).

All the kaleidocycles discovered thus far were beautifully symmetric. As they turned, the triangular faces met, matched, and then parted. Another question could not be ignored: Could other grids of triangles produce a different kind of kaleidocycle? Again, experimentation and use of geometry produced an answer. A slanted grid of triangles would produce a twisted ring of tetrahedra (Figure 12). Each twisted kaleidocycle has a jagged, uneven appearance and its tetrahedra seem

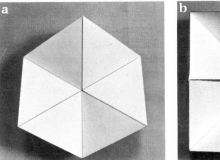

Figure 10. (a) A hexagonal kaleidocycle. (b) A square kaleidocycle.

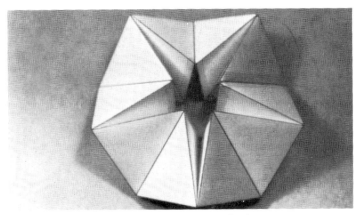

Figure 11. A starlike kaleidocycle of ten tetrahedra.

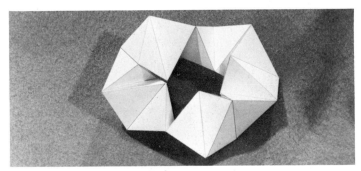

Figure 12. A twisted kaleidocycle.

to tumble through the center hole one at a time in sequence.

The many-faceted kaleidocycles seem to invite surface decoration. Many pleasing geometric effects can be produced by coloring the facets or adding lines to accentuate the kaleidoscopic nature of their movement (Figure 13).

While investigating these forms, the author was also studying and teaching the mathematical art of repeating patterns. The designs of M. C. Escher were a major source of illustrations in this study. Fragments of these patterns appear in many of his prints. Observing his prints, it was clear that the kaleidocycles captured two of Escher's dominant themes — a closed cycle and endless movement. *Reptiles* (Figure 3) and *Encounter* (Figure 14) are just two of many prints by Escher which contain part of an interlocking, repeating pattern and suggest an endless cycle of motion.

An idea for decoration of the kaleidocycles came naturally — could they be covered continuously with Escher's designs? If so, they would simultaneously bring to life in three dimensions many aspects of Escher's work. Ultimately, the answer was yes, but in order to understand how it was accomplished, we must first discuss some aspects of repeating patterns.

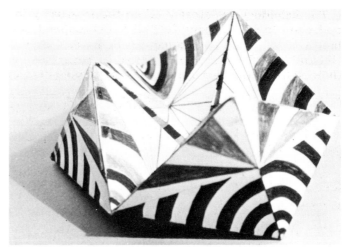

Figure 13. Bold geometric decoration accents a kaleidocycle.

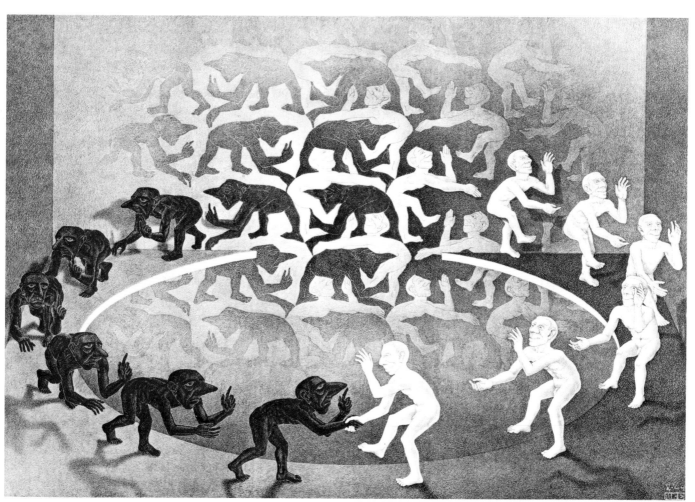

Figure 14. *Encounter,* lithograph, 1944. National Gallery of Art, Washington, D.C. Gift of Mr. C.V.S. Roosevelt.

Everyone knows what it means to tile a floor: many tiles, all alike, or perhaps of a few different shapes, are fitted together like a jigsaw puzzle to cover the floor without gaps or overlaps. Although the tiles can be placed in a somewhat random manner, usually they form a pattern which repeats itself at regular intervals. Such a pattern is called a repeating or periodic tiling of the plane (plane tessellation). These tilings were a constant preoccupation of M. C. Escher — even he called his fascination "a hopeless mania."*

The formation of such tilings is a child's exercise if the tiles are restricted to the three shapes of equilateral triangle, square, and hexagon. Escher's self-imposed restriction on tilings was that the tiles be recognizable, animate forms (allowing, of course, fanciful imaginary creatures). He records his early struggles in producing such tilings, having no other guidance than his own intellect. Later, he became aware that mathematicians and crystallographers had abstractly analyzed all such patterns and formulated rules which every periodic pattern had to obey. This knowledge was the necessary key to free Escher from frustrating experimentation and allow the full force of his creative talent to bring forth creatures that he could be sure would interlock in a prescribed way. He filled notebooks with over one hundred and fifty color sketches of fanciful repeating patterns. In *Reptiles* (Figure 3) it is from the page of one of these notebooks that an Escher-created creature decides to escape, only to reenter his jigsaw world.

A repeating pattern by its very definition can be superimposed on itself by sliding it a certain distance in a prescribed direction. This motion is called by mathematicians a *translation* of points in the plane. If we pick a particular point in a pattern, then find every repetition of this same point by translations, a lattice, or an array of points, is formed (Figure 15). This lattice will have the same formation no matter what point was first chosen. Lines can be drawn through the parallel rows of lattice points to form a grid of parallelograms; a third set of parallel lines can bisect these to yield a grid of triangles. Every repeating pattern, no matter how strangely shaped its tiles, has an underlying grid of lines — and both the parallelogram grid and the triangular grid form tilings themselves, but of simple tiles, all alike. Although the lattice of points associated with each periodic pattern is unique, these points can be

connected in many different ways, resulting in many different parallelogram and triangular grids. Mathematicians use these underlying geometric grids to analyze repeating patterns, choosing particular standard grids for this analysis.

A periodic pattern may be superimposed on itself by motions other than translations; such motions are called the *symmetries* of the pattern. Amazingly, there are only three other distinct motions which can be symmetries of a pattern. There may be a point in the pattern which can act like the center of a pinwheel. The pattern can be turned about this fixed point, and after less than a full turn, the pattern will be superimposed on itself. This motion is called a *rotation* (Figures 16 and 17).

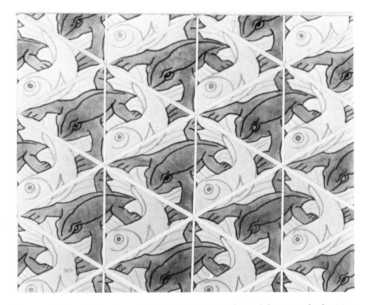

Figure 15. Periodic drawing 50; VII 1942. Fish and frog study for *Verbum*. Choose a point in a periodic pattern (the point chosen here is where the legs of three frogs meet), and find all repetitions of that point. This array of points is the *lattice* of the pattern. Joining rows of points forms a parallelogram grid (heavy white lines); these parallelogram tiles are all alike and reproduce the original design. Bisecting the parallelograms (thin white lines) produces a triangular grid. Each parallelogram contains exactly one frog and one fish (even though the lines break up the motifs). This same lattice of points can produce other parallelogram grids, such that every intersection of grid lines is a lattice point, and no lattice point is inside a parallelogram. These other parallelograms, even though differently shaped from those shown above, will have the same area as those shown above and will also contain one fish and one frog.

*See Escher's preface to Caroline MacGillavry's book.

Figure 16. Periodic drawing 35; VII 1941. Lizards. Each point marked with a small square is a center of four-fold rotation for the pattern. Thus, holding such a point fixed, the pattern can be rotated a quarter turn (90°) about that point and be superimposed on itself. The circles mark centers of two-fold rotation; a half turn (180°) about these points superimposes the design on itself.

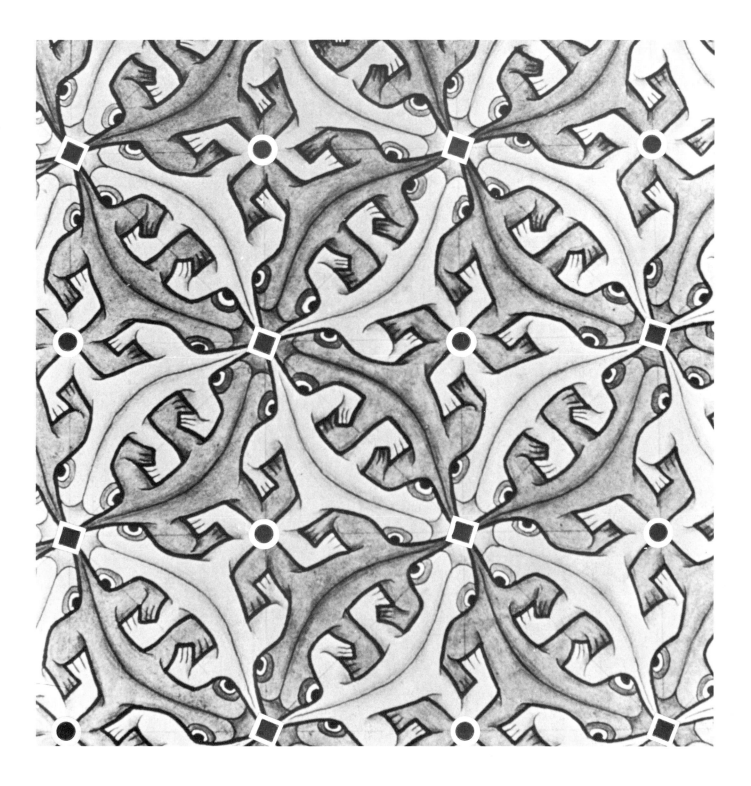

Figure 17. Periodic drawing 44; XII 1941. Birds. This design has centers of six-fold rotation (marked with ✳), centers of three-fold rotation (marked with △), and centers of two-fold rotation (find them!). Rotating the pattern 60° about the centers of six-fold rotation superimposes the outline of the pattern on itself but interchanges gray and white birds. Rotating the pattern 120° about the centers of three-fold rotation superimposes the birds of the same color.

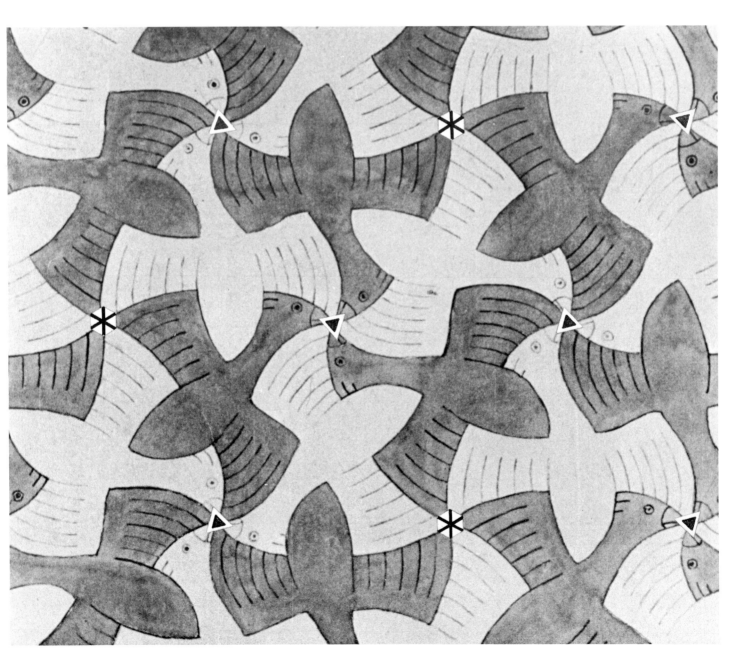

If a line can be drawn in the pattern so that the pattern on one side of the line is the mirror image of the pattern on the other side of the line, then the pattern can be superimposed on itself by flipping it over so that the line stays fixed (Figure 18). This motion is called a *reflection*, and the mirror line is called an axis of reflection.

Finally, it may be necessary to combine the motions of translation and reflection to superimpose a pattern on itself — first sliding along a line, then flipping the pattern over this line (Figure 19). This motion is called a *glide-reflection*.

The study of these motions is called *transformation geometry*, and its laws govern all repeating patterns. The actual process of creating a motif which will interlock with replicas of itself to fill the plane is, in Escher's words, "a complicated business." Mathematically, there are only seventeen distinct types of patterns (that is, patterns which have different symmetries), but artistically, there are an infinite number of possibilities. In creating a tile that will work, the artist must obey the constraints on its outline dictated by the possible symmetries of the design. Far more difficult is the creation of an outline which simultaneously defines the two shapes it will border in the design.

With this brief glimpse of the geometry which underlies repeating designs, we can now explain how the models in our collection were decorated.

Figure 18. Periodic drawing 85: IV 1952. "Three Elements." An axis of reflection bisects this design into two parts which are mirror images of each other. The design contains a whole grid of such reflection axes which split each motif.

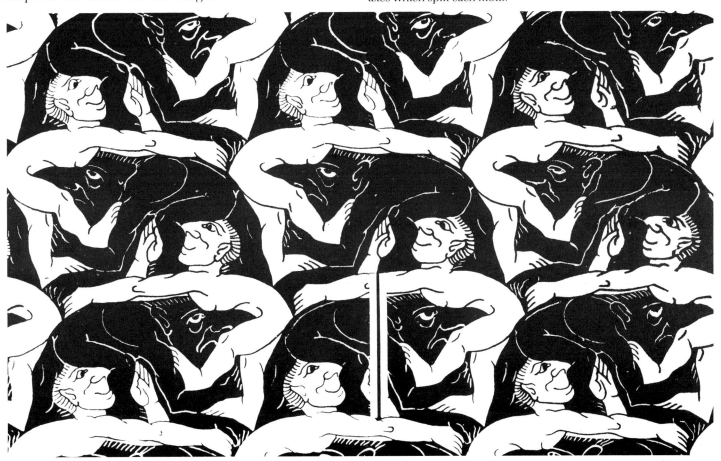

Figure 19. Periodic drawing 63; II 1944. Study for *Encounter*. Glide this pattern over itself along the "track" shown; flip the pattern over after traveling the length of the track. This glide reflection will take the optimists facing left, glide them upward, and then superimpose them on the next row of optimists facing right.

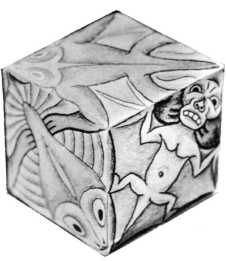

Figure 20. This cardboard model (two views) of a rhombic dodeca-hedron (twelve diamond-shaped faces) was covered by M. C. Escher with a version of his design shown in Figure 18.

Escher himself experimented with decorating the sur-faces of three-dimensional objects with his repeating designs. In the essay "Approaches to Infinity,"* he notes that the flat designs represent the possibility of infinite repetition but only a fragment of this infinity can be captured on a sheet of paper. On the surface of a three-dimensional object, infinite repetition of design can be realized with only a finite number of figures — the pattern on a solid has neither beginning nor end. In his experimentation he decorated a few cardboard models (Figure 20), but only one decorated solid was ever produced in finished form: a tin box icosahedron with an enamel design of shells and starfish which was commissioned by a Dutch firm to commemorate an anniversary (Figure 21).

Escher also created spheres whose carved surfaces are filled with a single repeated motif (Figure 22). It is likely that in covering these spheres with adaptations of his flat designs he first envisioned the pattern wrapped around a suitable solid such as a cube or octahedron, then projected the designs outward to the surface of a sphere surrounding the geometric solid.

The three Platonic solids with triangular facets and the cube have flat patterns cut out from grids of equilat-eral triangles or squares. Finding suitable designs to cover these solids is easy, for these grids are common for repeating designs. Covering these solids is not totally trivial, however, since when pieces of the repeat-ing design are cut out to make the pattern for the solid, the designs which are brought together in folding up the pattern may no longer match.

The cuboctahedron is also easily covered, provided designs filling both triangle and square grids can be matched. Escher had produced such designs as a

*This is reproduced in *The World of M. C. Escher.*

Figure 21. M. C. Escher designed this enameled tin icosahedron (1963). National Gallery of Art, Washington, D.C. Gift of Mr. C. V. S. Roosevelt.

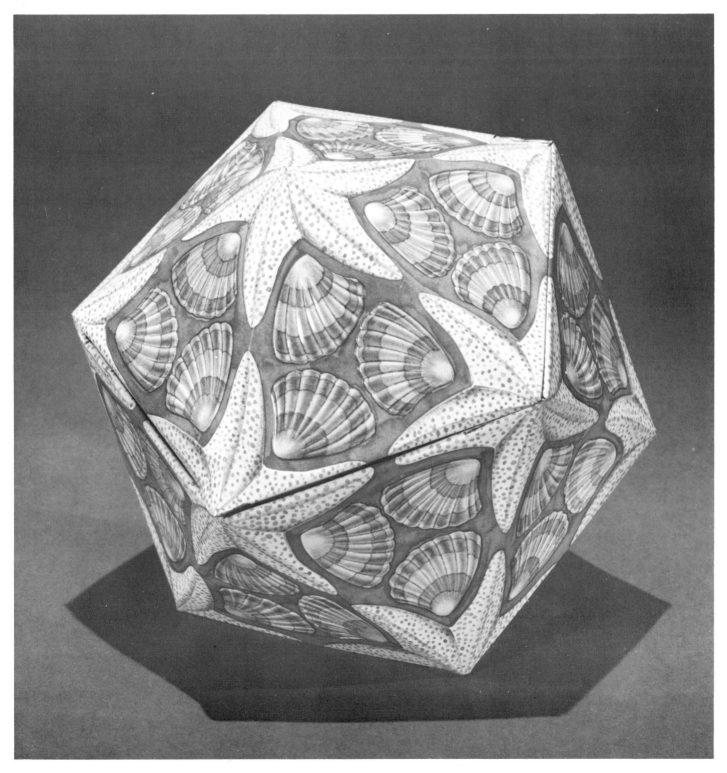

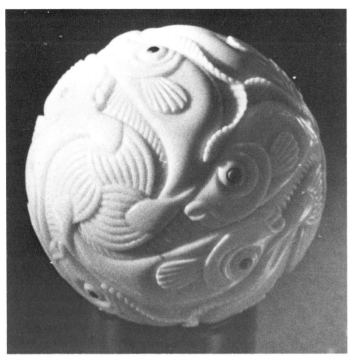

study for his *Circle Limit III* (Figure 23). Although it was necessary to distort the triangular and square tiles to cover a representation of a special curved surface called a *hyperbolic plane*,* Escher's print is one in which matching squares and triangles alternate.

Decoration of the dodecahedron presented the greatest challenge of all the solids. Since regular pentagons are not the geometric grid of any repeating design, something more complicated than just cutting out a design and wrapping it around this solid was required. Here, familiarity with a special tiling of the plane by nonregular pentagons was the key to success. Combining this knowledge with the technique that Escher must have used to cover his spheres, we were successful in covering the dodecahedron with an Escher design. (Details of the decorations on all of the solids appear later in the *Notes on the Models.)*

*A hyperbolic plane is a surface having the property that given a line and a point not on the line, at least two lines can be drawn through the point which do not intersect the line.

Figure 22. An ivory replica of Escher's "Sphere with Fish," carved in 1962 by Masatoshi, a Japanese netsuke carver. National Gallery of Art, Washington, D.C. Gift of Mr. C. V. S. Roosevelt.

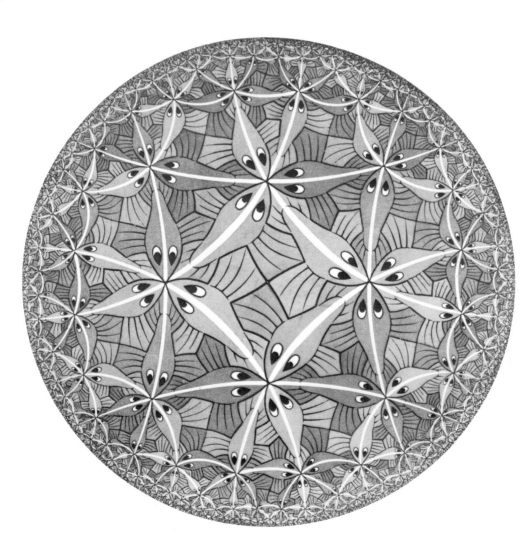

Figure 23. *Circle Limit III*, woodcut in four colors, 1959. National Gallery of Art, Washington, D.C. Rosenwald Collection.

In discussing the problem that the drawings of repeating designs inadequately represent true infinite repetition, Escher proposed a partial solution to this dilemma. If the flat design sketched on a rectangle of paper (Figure 24a) is lifted up and two opposite edges brought together, matching the design, then a cylinder is formed (Figure 24b). At least in the circular direction the design will have neither beginning nor end on this surface. But, of course, the cylinder has only finite height so the repetition abruptly stops at the top and the bottom of the cylinder. A form with true infinite repetition could be created by beginning with a flat rectangle, bringing together the top and bottom edges to form a cylinder, and then bringing together the ends of this cylinder to form a closed ring. An ordinary cylinder cannot have its ends brought together to form a ring without crushing the paper. The reason we can accomplish this feat in making a kaleidocycle is because our paper has been scored and folded so that the first "cylinder" we form is creased into a chain of tetrahedra and it is easy to bring the ends of this chain together to form a closed ring without any crumpling of the paper (Figure 24c). Thus, the kaleidocycle form has infinite repetition of its triangular facets in two distinct circular directions, like the surface of a doughnut. Continuously covering the surface of the kaleidocycles with repeating designs accomplishes a solution to the problem proposed by Escher.

The actual decoration of the kaleidocycles with Escher's periodic designs was not as easily accomplished as the process outlined above might indicate. The hope that this could be realized was sparked by a simple observation that both the periodic designs and the patterns for the kaleidocycles have a common geometric aspect. Each of the kaleidocycles grows out of a flat grid of triangles — and such a grid is also associated with repeating patterns. Simply to superimpose a repeating design with a given grid onto the pattern of a kaleidocycle formed from the same grid seemed to be

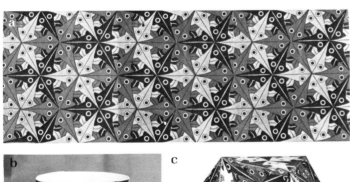

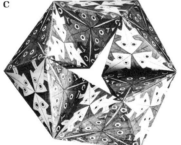

Figure 24. Repetition of periodic drawing 103; IV 1959. Fish. (a) This rectangular portion of a periodic design of red, white, and black fish has left and right edges matching, top and bottom edges matching. (b) A cylinder is formed when either pair of matching edges is brought together. (c) If the design is creased along the grid lines of a kaleidocycle, *both* pairs of matching edges can be brought together and the pattern "wrapped around" the kaleidocycle.

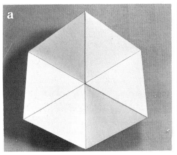
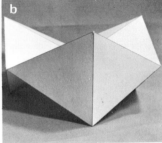

Figure 25.
(a) A top view and (b) a side view of a hexagonal kaleidocycle.

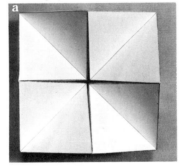
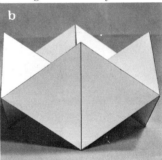

Figure 26. (a) A top view and (b) a side view of a square kaleidocycle.

an obvious thing to try, but, unfortunately, this was too naïve to work. Viewed from above, a hexagonal kaleidocycle appears to be six equal triangles forming a regular hexagon (Figure 25a), and a square kaleidocycle appears to be eight equal triangles forming a square (Figure 26a). It *looks* as though a repeating design with a grid of equilateral triangles should cover the facets of the hexagonal kaleidocycle; it *looks* as though a design with a grid of right triangles should cover the facets of the square kaleidocycle. But our eyes are playing tricks, since in the top view, the triangular facets of these three-dimensional forms are actually slanted. Side views of the models (Figures 25b and 26b), or a closer inspection of their flat patterns, reveal that their triangular facets are not the same triangles which underlie the repeating designs.

A camera projects the three-dimensional image it sees onto a flat plane. It is also possible to reverse this process and project a design in a flat plane onto a three-dimensional object. Why not *project* a design with equilateral triangles in its grid onto the hexagonal kaleidocycle viewed from above? Similarly, why not project a pattern with right triangles onto the face of a square kaleidocycle? In order to carry this out, another geometry was needed. *Projective geometry* tells us which properties of objects are not changed when the image of the object is projected onto another surface.

There are two essentially different ways to project an image. The first, called a *central projection* (Figure 27), is familiar to us in the way a slide projector works. A single-point source of light sends out a cone of light rays which stretch the image and carry it onto another surface. The other type of projection is technically harder to carry out, but mathematically just as natural as the first. In a *parallel projection* (Figure 28), the image is projected to another surface by rays which are all parallel to each other, all moving in the same direction. Each type of projection preserves some properties and distorts some properties of the original image. The essential properties of the repeating designs which had to be preserved if the kaleidocycles were to be covered continuously were preserved by a parallel projection (Figure 29b) but not by a central projection. Thus, in theory at least, the problem of projecting the repeating patterns onto the surfaces of the kaleidocycles was solved. (The actual process of producing a parallel projection can be done by a computer or via photography using a complicated system of lenses.)

Now only one question remained: What patterns could be wrapped around the hexagonal or square kaleidocycles? In turning these rings of tetrahedra, the triangular faces come together and then part. Many different edges match as the forms turn cartwheels through their endless cycle. Patterns suitable for decoration must have the proper symmetries so that the design will always match when edges come together. In addition, the design must fill the flat pattern of the kaleidocycle so that top and bottom edges match and left and right edges match. Many patterns were found that fulfilled these requirements and so the theoretical possibility of continuously decorated kaleidocycles became a reality.

The actual process of producing the decorated forms ready for you to assemble required a most exacting procedure. Although the sketches of repeating designs in Escher's notebooks appear to be quite precise, the hand-drawn repeating motifs contain tiny variations as they fill a page. When covering a kaleidocycle, motifs from different parts of a pattern must match as the kaleidocycle rotates, so extreme precision is necessary for the surface design. Each repeating design used on the solids and the kaleidocycles was hand-drawn to

these exacting requirements. Very literally, Wallace Walker and his assistants — Victoria Vebell, Robert McKee, and Robin McGrath — retraveled Escher's path in recreating the designs.

Once precise, the kaleidocycle designs were stretched by a special photographic process to carry out the parallel projection described earlier. Finally, the designs were carefully hand-colored. In all cases, an attempt was made to match the colors of Escher's original sketches as closely as possible.

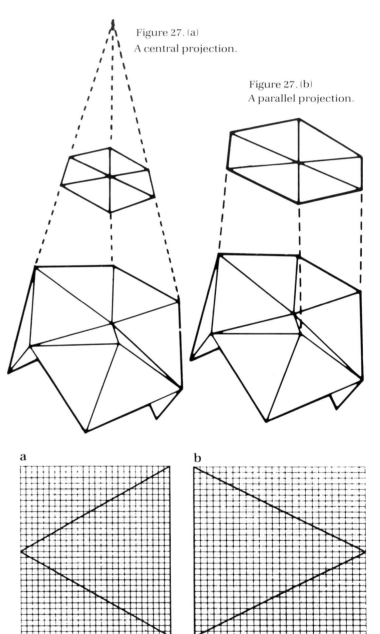

Figure 27. (a) A central projection.

Figure 27. (b) A parallel projection.

Figure 28. (a) An equilateral triangle, drawn on ordinary graph paper, (b) is parallel-projected by a computer onto the face triangle of a hexagonal kaleidocycle shown at the right. Note that the distance between parallel lines remains unchanged in one direction and is stretched uniformly in the other direction.

Escher had a rigid criterion for coloring all of his repeating patterns. Any two adjacent motifs must have different colors. Only by color contrast can a single motif be distinguished in a design filled with replicas of this motif.

Mapmakers are usually required to color each country with a single color and us enough different colors so that countries which border each other have different colors. Strange as it may seem, the problems that arise in meeting these coloring requirements are in the domain of mathematics. Given a design (a map of countries, a geometric design, a tiling), mathematicians ask questions like these: How few colors can I use to meet the coloring requirements of the map? How many different ways can I color it? Can it be colored so that certain color combinations must occur? These questions are often surprisingly hard to answer if the design is complicated or the coloring must meet stringent conditions. Combinatorics, graph theory, and topology are all branches of modern mathematics in which these questions are considered.

The problem of determining the smallest number of colors that suffice to map-color *any* design drawn on a plane or surface of a sphere was unsolved for over one hundred years, although many skilled mathematicians attempted to answer it. Many believed that four colors was the answer since no one was able to produce a map that required five colors. Only in 1976 was this answer conclusively proved to be correct. (Mathematicians K. Appel and W. Haken of the University of Illinois used tens of thousands of computer operations to support their proof.) Although four colors are sufficient to map-color any plane design, a repeating design is most pleasingly colored if the coloring emphasizes the symmetries of the design. Escher experimented with and categorized many of these special types of colorings long before the subject became a field of investigation for crystallographers and mathematicians.

In adapting Escher's designs to the surface of the geometric models, the criterion that the design must be map-colored was maintained. When the flat patterns of the solids are cut out from the geometric grids underlying Escher's periodic designs, naturally some portions of the design are cut out. When a pattern is folded up to form a solid, different portions of the periodic design are brought together, and in some cases, this causes adjacent motifs on the solid to have the same color. In order to have the design on these solids map-colored,

some adjustments in Escher's coloring had to be made. Sometimes a design which required only three colors in the plane demanded a fourth color when applied to the surface of a geometric solid. In three cases—the cube, the icosahedron, and the cuboctahedron—the map-coloring requirement forced a rearrangement of colors.

On all of the models, an additional coloring requirement was also met: Each patterned solid can be colored *evenly*, that is to say, each different color is used the same number of times. Finding such a coloring for the cube (Model 4) has been left as a puzzle for you to solve.

Figure 29. The fish design on the cuboctahedron can be map-colored evenly using a minimum of three colors. In the coloring shown here, each color (white, gray, and black) is used on exactly eight of the twenty-four fish which cover the cuboctahedron. Other interesting even map-colorings of this design are possible using four colors; we chose one of these for our model (see page 27).

21

a

Figure 30. (a) Periodic drawing 56; XI 1942. Reptiles. (b) An axis of three-fold rotational symmetry. (c) An axis of two-fold rotational symmetry.

1. Tetrahedron

This design of reptiles was a natural choice to cover the tetrahedron. Joining the points of six-fold rotation forms a natural grid of equilateral triangles (one of which is shown in Figure 30a), and the tetrahedron pattern consisting of four of these triangles easily wraps the design around the solid with both outlines and colors of the creatures matching. On the surface of the solid the centers of rotation of the flat design become centers of rotation of the solid. For example, if an axis is inserted through the tetrahedron so that it pierces the center of one triangular face and the vertex opposite that face, then the tetrahedron can be rotated 120° about that axis and be superimposed on itself (Figure 30b). This rotation of the tetrahedron about such an axis is called a three-fold rotational symmetry of the tetrahedron. You will see three reptiles turning around each of the points where a three-fold rotational axis can pierce the tetrahedron. The midpoint of each edge of the tetrahedron is a center of two-fold rotation, both for the periodic design and for the tetrahedron. A two-fold rotation axis for the tetrahedron will pierce through the midpoints of two nonadjacent edges (Figure 30c).

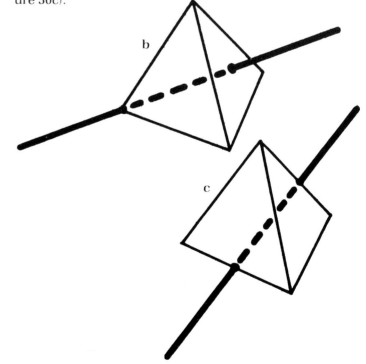

Figure 31. (a) Escher's instructions and (b) plastic sketch ball for carving of (c) the ivory sphere with "Three Element" design. Clearly visible is the spherical triangle which contains half of each of the three motifs. This triangle is the projection of (d) one face of our octahedron onto the surface of the sphere. Photo (b) National Gallery of Art, Washington, D.C. Gift of Mr. C. V. S. Roosevelt.

2. Octahedron

The repeating design depicting the "Three Elements" of earth, water, and sky (Figure 18) was used by Escher as he experimented with surface decoration of three-dimensional forms. Each motif in the pattern approximately fills a diamond shape (rhombus) of two joined equilateral triangles. By altering the dimensions of these decorated diamonds, they can become the faces of a rhombic dodecahedron. In this way, Escher wrapped a distortion of the flat periodic design around the twelve-sided solid (Figure 20). He also covered a prism with this design.

In 1963, at the suggestion of C. V. S. Roosevelt, an avid collector of his work, Escher provided a detailed drawing (Figure 31a) and plastic ball covered with the design (Figure 31b) to guide the Japanese craftsman Masatoshi as he carved the design onto the surface of an ivory sphere (Figure 31c).

The most obvious adaptation of this design to the surface of a geometric solid is to cover an octahedron. No distortion of the flat pattern is required. Each equilateral triangle containing the interlocked halves of the three motifs is a face of the octahedron (Figure 31d). Twelve motifs in all, four of each kind, cover the octahedron, and the four replicas of each motif form a square path traveling around adjoining edges of the octahedron.

If the octahedron is surrounded by a sphere and this design is centrally projected onto the surface of the sphere, Escher's decorated ball is the result. Under this projection the square path followed by replicas of a single motif becomes a great circle on the sphere.

Escher was very specific in his instructions as to the coloring of the decorated ivory sphere and included samples of the three colors he wished to be used. The coloring of our decorated octahedron is Escher's choice for his decorated sphere. Note that it differs from the coloring of the original periodic design; we have used the latter in our decoration of a hexagonal kaleidocycle with the same three-element design.

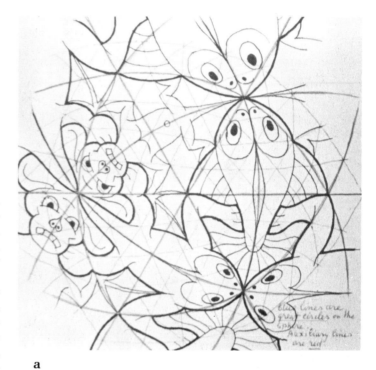

a

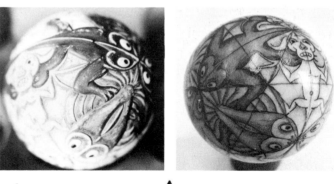

b

c

d

3. Icosahedron

Escher's periodic design of butterflies (Figure 32) is one of the most intricate and carefully colored ever done by him. Any of Escher's patterns which contain centers of six-fold rotation could be adapted to cover the icosahedron, but the beautiful butterfly design proved to be a special challenge. The flat design requires three colors for recognition of adjacent butterflies, and Escher provided a coloring in which just two of the three colors alternate about each six-fold center of rotation (where six wing tips meet). In addition, Escher emphasized the missing third color from the butterflies about a given center of six-fold rotation by using this third color for the wing markings (the small circles) on the butterflies whirling about that point. These centers become the vertices of the icosahedron when the flat pattern of the icosahedron is cut out from the grid of equilateral triangles which underlies the butterfly design. Thus, just five of the six butterflies whirl around each vertex of the solid and the coloring must be altered so that adjacent butterflies have different colors.

It is quickly discovered that four colors are required on the solid in order to fulfill this condition. The challenge was to make the new coloring as balanced as possible. Although the coloring achieved may appear somewhat random, it possesses unusual balance. Around each vertex of the solid just three of the four colors are used. Following Escher, the wing markings of the butterflies whirling about a vertex contain the fourth color not used to color the butterflies about that vertex. Every possible combination of using two colors twice and a third color once to color the five butterflies around one vertex occurs. (For example, using the colors green, blue, and pink, there are exactly three different colorings of vertices of the solid: (1) green twice, blue twice, pink once; (2) green twice, pink twice, blue once; (3) blue twice, pink twice, green once.) Finally, it is an *even* coloring, that is to say, of the total of sixty butterflies that cover the solid, exactly fifteen of each color occur.

This is the only model in which a new color had to be introduced. Escher used green, blue, and pink to color his flat design of butterflies. Yellow was added to solve this three-dimensional coloring puzzle.

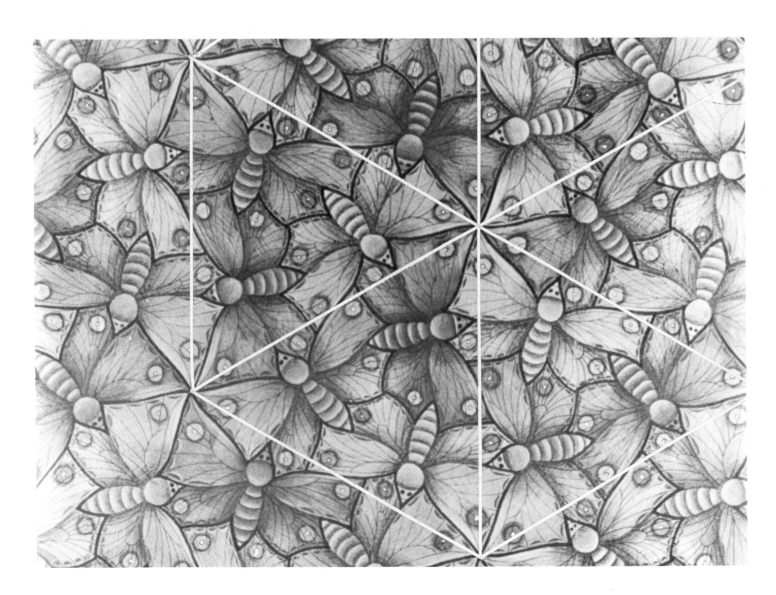

4. Cube

Directly related to Escher's own "Sphere with Fish," this cube can be viewed as an intermediate stage in transforming a two-dimensional tiling of the plane (Figure 33) to a tiling on the surface of a sphere. The single fish tile fills the plane in a pattern which has two different points of four-fold rotation: four fish whirl around the point where their tails meet and another four fish spin around the point where their back fins meet. Escher has symbolized with small squares these centers of rotation on his single fish tile. Joining these points of the pattern forms a square grid from which we cut out the pattern of a cube. Now fold up the cube — it is covered with twelve fish and at each corner of the cube three fish whirl. If we could inflate this cube into a sphere, it would become Escher's own "Sphere with Fish."

It is quite possible that Escher devised his own carved wooden sphere in this manner. In giving instructions (Figure 34) for a small replica of the sphere to be carved from ivory (Figure 22), Escher noted that the three-fold points of symmetry on the sphere should be where an inscribed cube would touch the surface of the sphere.

In his notebook, Escher remarks below his repeating design with fish that it is possible to use just three colors to map-color the design. However, he chose to use four colors since this coloring was more compatible with the symmetry of the design. The design wrapped around the cube demands four colors to be map-colored. Escher's carved sphere with fish is uncolored, and so we have left our cube uncolored. You are challenged to solve the following coloring puzzle:

Color the fish on the cube so that all of the following conditions are met: (1) Each fish is one color. (2) No two adjacent fish have the same color. (3) Exactly four colors are used. (4) Each color is used to color exactly three of the twelve fish. (Yes, it can be done! We have provided a small replica of the cube for you to practice on.) When you have accomplished this, you have an example of an even coloring of a "map" on a sphere which requires four colors.

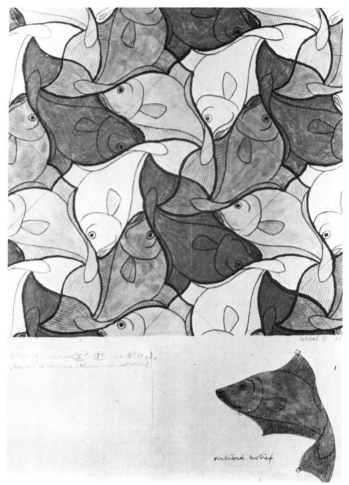

Figure 33. Periodic drawing 20; III 1938. Fish.

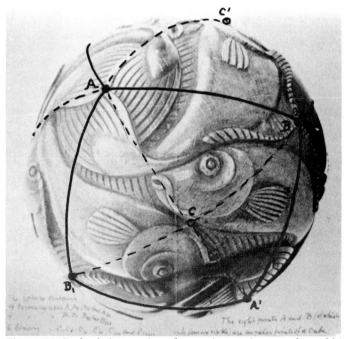

Figure 34. Escher's instructions for carving an ivory replica of his "Sphere with Fish." His outline on the photograph of his carved wooden sphere shows a projection of one face of our cube (Model 4). He notes, "The eight points A and B (of which only four are visible) are angular points of a cube."

Figure 32. Periodic drawing 70; III 1948. Butterflies. Pink and green butterflies alternate around the six-fold center of rotation ✳ These two colors are sufficient to map-color this portion of this design in the plane. However, one butterfly must be cut out in order to adapt this design to the surface of an icosahedron (the center of rotation becomes a vertex), and thus at this vertex two butterflies of the same color will be adjacent. In order to have adjacent butterflies on the icosahedron always different colors, four colors are necessary to color the design on the solid.

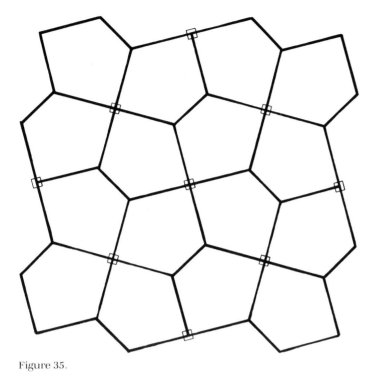

Figure 35.

5. Dodecahedron

Regular pentagons cannot be used as tiles to fill the plane — there will always be gaps in such a tiling. How, then, could the dodecahedron be covered with a repeating design?

One of Escher's favorite geometric patterns was the tiling by pentagons shown (Figure 35). These pentagons are not regular since their angles are not all equal. On the pattern we have marked the centers of four-fold rotation; these can be joined to form a square grid of lines. From this grid we can cut out the flat pattern of a cube and fold it up into a solid cube.

Escher's periodic design "Shells and Starfish" is based on this geometric pentagonal tiling, with each starfish occupying one pentagon (Figure 36a). To decorate our dodecahedron with this design, we first wrapped it around the cube (Figure 36b). Examining the pentagon-covered cube (Figure 36b), two exciting observations indicate how to solve the original problem. First, exactly twelve pentagons are in the design covering the cube — and the dodecahedron has twelve pentagonal faces. Second, we know it is possible to inscribe a cube inside a dodecahedron so that each of its edges lies on a face of the dodecahedron, and each of its corners is at a vertex of the dodecahedron (Figure 36c). The lines of the pentagon pattern drawn on our cube are in the correct position so as to appear as though the edges of the dodecahedron have been projected onto the cube. The cube in Figure 36b was thus inscribed in a dodecahedron, and then the pattern was projected outward onto the surface of the dodecahedron. In this way the pattern was preserved (though distorted from its two-dimensional beginning), and continuously decorated the most unusual Platonic solid.

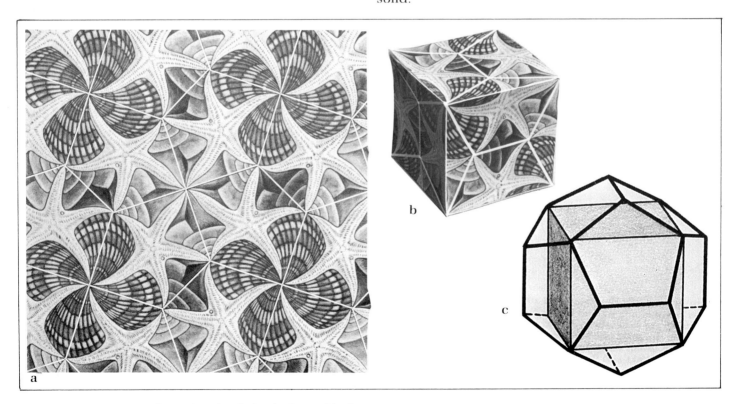

Figure 36. The process of covering the dodecahedron with the "Shells and Starfish" design. (a) Periodic drawing 42; VIII 1941. "Shells and Starfish" (with network of pentagons outlined). (b) The network of pentagons which underlies the design is projected outward from the surface of the covered cube to (c) the surface of the dodecahedron containing the cube.

6. Cuboctahedron

A floor can be tiled in a variety of ways using equal-sided triangles and squares so that their edges are matched. Three triangles and two squares fit exactly around a point in two distinct ways (Figures 37a and b). In any tiling using both types of tiles, one or both of these arrangements must occur.

A single page in Escher's notebook contains a triangular tiling and a square tiling with the same fish motif (Figures 38a and b). If we attempt to use both Escher's triangular and square fish tiles to fill a plane, we quickly note that in either arrangement of the tiles around a point it is impossible to have all of the fish "match" (Figure 39). (This is because an odd number of tiles surrounds a point.) However, the flat pattern of the cuboctahedron can be cut out from a plane-filling design of squares and triangles (Figure 40a) in which the odd nonmatching tile is omitted at each vertex so the fish will match when the pattern is wrapped around the solid cuboctahedron.

Circle Limit III (Figure 23) was Escher's solution to combining these tiles in a two-dimensional representation. He distorted them mathematically so they could fill a non-Euclidean plane with an even number of tiles surrounding each vertex, and thus achieved a matching of tiles.

Escher's periodic fish tiling using all square tiles requires only two colors; the one with all triangular tiles needs three. In combining the two types of tiles in *Circle Limit III*, Escher used four colors for the design. The map-coloring criterion did not force him to do this, but he wanted to emphasize the "traffic flow" of fish swimming along the curved paths of the design. In his coloring, all fish along one path are of the same color and are surrounded by fish of different colors. This scheme made four colors necessary.

There are many pleasing ways to color the fish design covering the cuboctahedron, all of which meet the map-coloring requirement and use the colors "evenly."

The minimum number of colors necessary to map-color the design on our cuboctahedron is three, and a mathematically balanced coloring using just three colors is shown in Figure 29. In this coloring each trian-

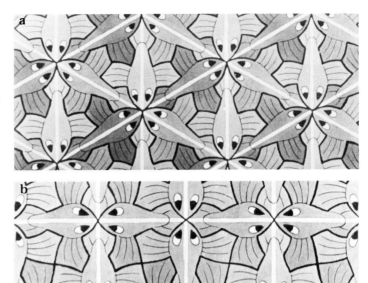

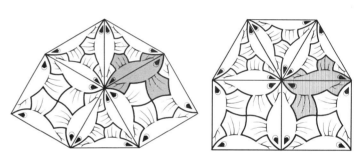

Figure 38. Periodic drawings 122(a) and 123(b); IV 1964. Study for *Circle Limit III*.

Figure 39. Square and triangular tiles can fill a plane, but Escher's fish tiles will not all match in such a plane tiling.

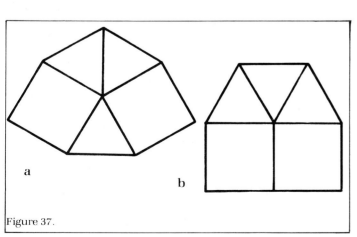

Figure 37.

Figure 40. A cuboctahedron pattern can be cut from the plane tiling, resulting in a matching fish design on the three-dimensional solid.

gular tile contains all three colors and each square tile contains just two of the three colors. Each color is used on exactly eight of the twenty-four fish covering the solid.

If we follow Escher and choose to use four colors for the design, two particularly interesting colorings result if we follow a chosen aspect of Escher's coloring of *Circle Limit III*. To emphasize the "traffic flow" of fish around natural paths encircling the cuboctahedron is one possibility. On the surface of the cuboctahedron there are four natural hexagonal paths formed by six adjacent edges which encircle the solid. Using Escher's idea, we can color all fish on a single path the same color. In doing so, all twenty-four fish are colored, six of each color, and the coloring produced has all possible circular arrangements of four colors occurring on the square faces and all possible circular arrangements of three out of four colors occurring on the triangular faces.

Another possibility is to create an even four-coloring of the design in which square faces contain just two colors and triangular faces, three colors, as in *Circle Limit III*. Such a coloring is the one we have chosen for our pattern. Visually, this coloring appears to be the more closely related to the two-dimensional coloring by Escher.

Every pattern which decorates these kaleidocycles begins with an underlying grid of equilateral triangles. All the patterns have three-fold centers of rotation; some have two-fold and thus six-fold centers of rotation as well. Some have reflection symmetries. Look for these symmetries as you examine the assembled models.

7. Bugs

This pattern (Figure 41) appears almost abstract, like a rich brocade, when viewed from a distance — only close examination reveals the interlocked bugs. Each triangle, like the one outlined, decorates a single face of the kaleidocycle. At the center of this triangle is a three-fold center of rotation; the edges of the triangle are reflection axes for the pattern. Turning the kaleidocycles matches mirror images of bugs. This completes the design, and reveals another three-fold center of rotation at the center hole of the closed ring.

Figure 41. Periodic drawing 54; X 1942. Bugs.

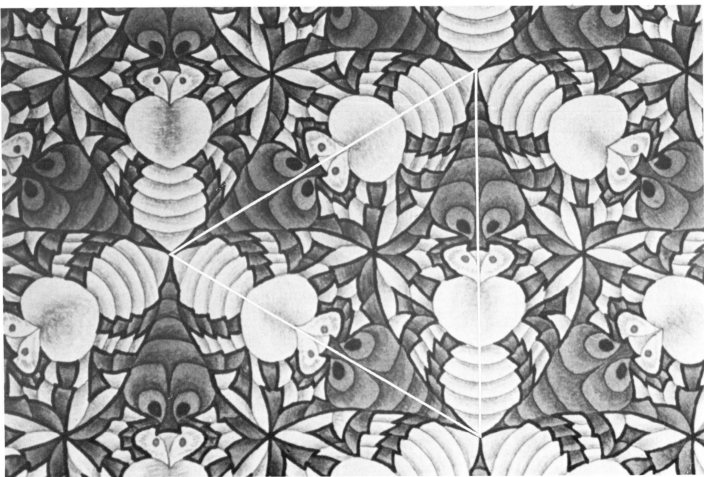

8. Fish

The symmetries of this repeating design (Figure 24) are exactly the same as those of the previous one, if we ignore coloring. Map-coloring each design reveals its difference: The bug design with two different creatures requires only two colors, while this design with just one motif requires three colors. Without color, the design formed by the fish has an underlying grid of triangular tiles like the small one shown in Figure 42a. With color, the design is composed of repetitions of the larger triangular tiles (Figure 42b). These larger tiles decorate the faces of this kaleidocycle. At the center of each face is a three-fold center of rotation which is also the point of intersection of three reflection axes of the pattern.

9. Bird-Fish

Look at the shape in Figure 43. What do you see? A silhouetted bird in flight? Yes, and look again with the imagination of a child. It is a soaring fish. One shape, yet two creatures can occupy that outline. The shape is a tile which can fill the plane, and thus the pattern it creates can contain both creatures, one merging with the other (Figure 44).

How we perceive or interpret outlines — the fact that one silhouette can have many interpretations — provides part of the magical surprise of Escher's work. As you turn this kaleidocycle, you will witness a seeming metamorphosis of birds into fish and back again in an endless cycle. Yet if the detail of the creatures were blotted out, an allover pattern of one tile would be all that remained.

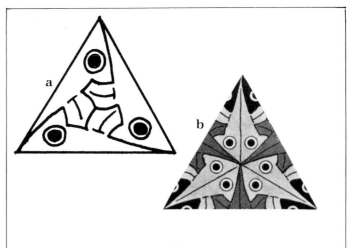

Figure 42.

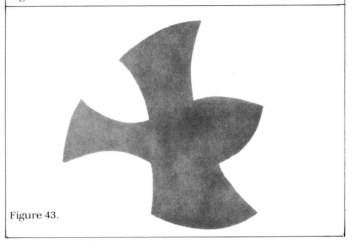

Figure 43.

Figure 44. A woodcut print from *Regelmatige Vlakverdelung* (Regular Division of a Plane), 1958. Here our silhouette becomes a soaring fish. (Escher's periodic drawing which was the study for this print contains the note "See no. 44," which is the periodic drawing of birds in our Figure 17.)

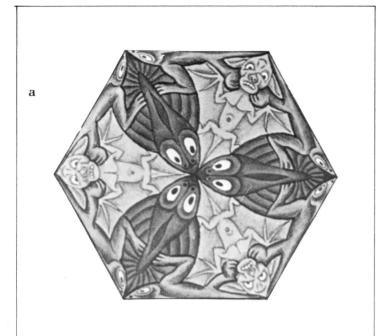

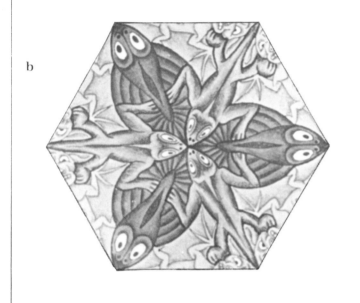

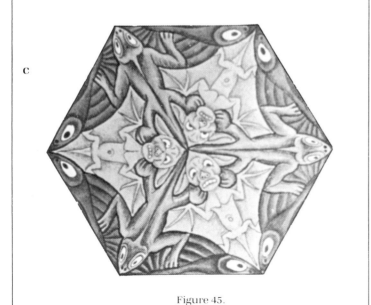

Figure 45.

10. "Three Elements"

Escher's "Three Elements" design (Figure 18) has three different centers of three-fold rotation. At one center, the heads of three fish meet (Figure 45a); at another, the heads of three lizards meet (Figure 45b); at the third, the heads of three bats meet (Figure 45c). We can animate this design by choosing as faces for the kaleidocycle the small triangles of the pattern which form the faces of our decorated octahedron (Figure 31d). Imitating the action of a kaleidoscope, each turn of this kaleidocycle clicks a new image into view. The design which covers three faces of this model cannot be continued onto the fourth face because a fact from the geometry governing the periodic design comes into conflict with a fact governing the three-dimensional form: The periodic design repeats the triangles we have chosen as faces for our model in strips of six, but the tetrahedra which make up the model have as their flat pattern triangles in strips of four. Thus, we have designed the fourth face of our model to contain Escher's name.

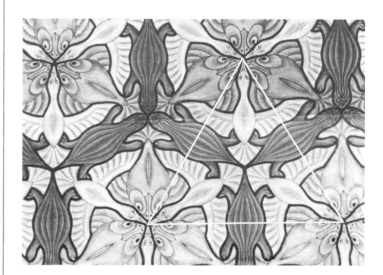

Figure 46. Periodic drawing 69; III 1946. Fish, Duck, Lizard (first version of "Three Elements").

11. Fish, Duck, Lizard

This repeating design (Figure 46) is mathematically the same as "Three Elements" (Figure 18). (Its creatures also represent air, land, and water.) Although we could have used this design to cover a kaleidocycle in the same manner as the "Three Elements" model described above, we decided to wrap this design continuously around a kaleidocycle. To accomplish this, a triangle larger than the one used for the "Three Elements" model (Figure 31d) is necessary to decorate the faces of the kaleidocycle. The triangles formed by joining the points of the design where the heads of three fish meet successfully cover the kaleidocycle.

12. *Verbum*

Fragments of Escher's repeating patterns most often occur in prints which depict metamorphosis. *Verbum* (creation) is one of the most skillful of these prints (Figure 47). The interlocking pairs of creatures were first sketched as simple plane-filling designs (Figures 48, 15) in which parallel rows of the creatures form a grid of intersecting lines. However, in incorporating these designs into *Verbum*, Escher used a subtle mathematical device to capture the themes of explosion, evolution, interdependence, and cycle.

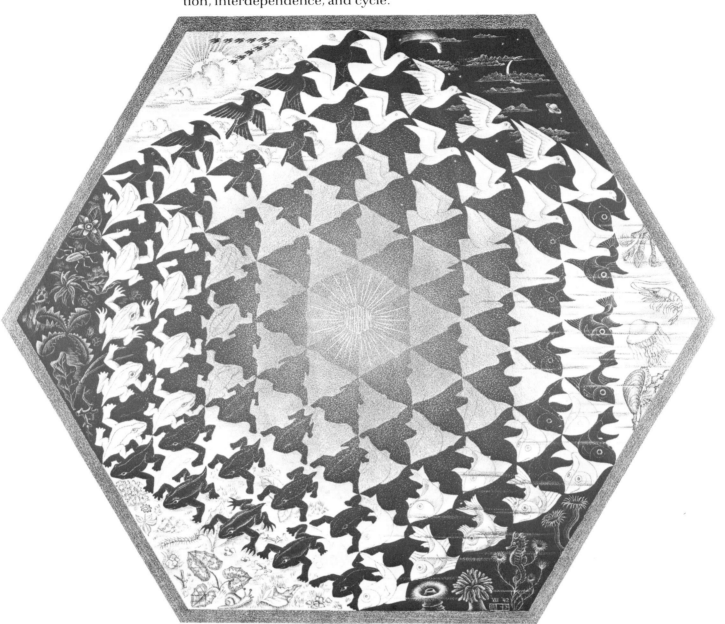

Figure 47. *Verbum*, lithograph, 1942. National Gallery of Art, Washington, D.C. Gift of Mr. C. V. S. Roosevelt.

Figure 48. The periodic design on the cover of *Regelmatige Vlakverdeling* is used in the interlocked bird portion of *Verbum* (at the top of the print). The cover design has been printed in reverse so that the birds have the same orientation as in *Verbum*. See Figure 15 for the periodic drawing of the frog-fish portion.

Verbum contains two distinct kinds of development. (Figure 49) From the center outward, vague amorphous shapes gradually evolve into recognizable creatures which escape into their natural element. In a circular sweep around the hexagonal ring (Figure 49), creatures metamorphose—bird into fish into frog into bird, tracing the ecological cycle of air, water, land. This double system of development, consisting of rays emanating from a single center and concentric circles about that center, is familiar to mathematicians in the polar coordinate system.

The design has been adapted to the kaleidocycle so that beginning with the explosion at the center of the print, each inward turn of the kaleidocycle produces a multiplication and evolution of the creatures, culminating in the total view of the print.

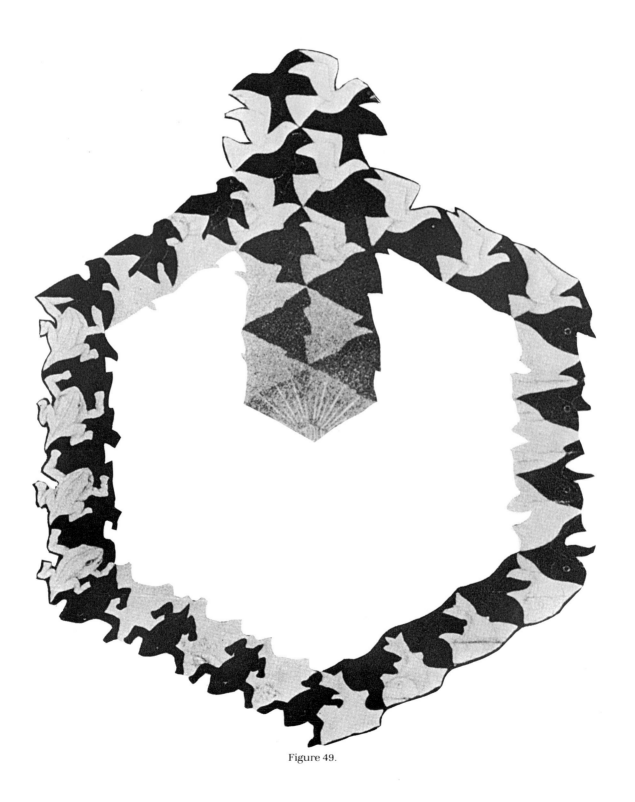

Figure 49.

Each of the patterns adapted to decorate the surface of a square kaleidocycle has as its underlying grid a mesh of squares like ordinary graph paper. All designs have centers of two-fold rotation; some also have reflection axes. At the center "hole" of each decorated kaleidocycle will occur a center of four-fold rotation.

Watch closely as you turn these models—each turn will change the image you view.

13. "Shells and Starfish"

This pattern has been discussed in describing the decoration of the dodecahedron (Figure 36a). This time we join the points in the pattern where four shells of the same kind meet to form a square grid. Each square is bisected into right triangles. (Two such bisections are shown in Figure 50.) Each of these triangles decorates a face of the kaleidocycle. As you turn the kaleidocycle watch the change of shells occur at the center point.

Figure 50. Periodic drawing 42; VIII 1941. "Shells and Starfish."

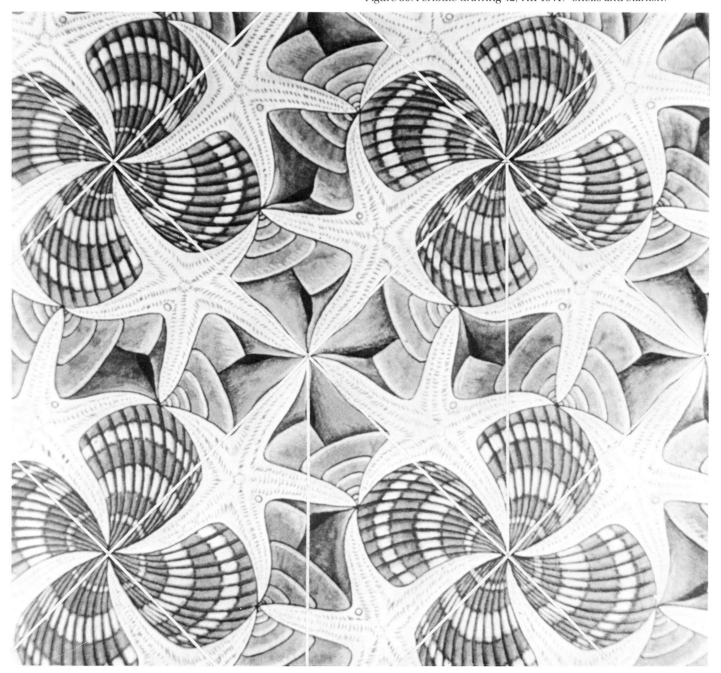

14. Flowers

The geometric network of pentagons in this design (Figure 51) is boldly visible. It is the same grid which invisibly underlies "Shells and Starfish" (see Figure 36a). Escher used this design as a fragment in his extended *Metamorphosis* print (Figure 52; see *The Graphic Work of M. C. Escher* for a reproduction of the complete 700-centimeter-long print). Escher's sketchbook page indicates that one square tile will produce the whole design. You will see his square at the center of the kaleidocycle as you view it from above.

A startling change in design takes place as you transform this kaleidocycle to its three-dimensional form. The design on the flat pattern is created by a red grid of hexagons intersecting at right angles a blue grid of hexagons; thus, each pentagon formed by these superimposed grids has some red edges and some blue edges. When viewing the design on the three-dimensional kaleidocycle, however, you will see that the pentagons now have all edges of the same color! Each turn of the kaleidocycle changes the color of the pentagons and their direction of rotation about the center point.

Figure 51. Periodic drawing 132; XII 1967. Flowers.

Figure 52. Fragment of *Metamorphosis*, woodcut, 1939-40 and 1967-68.

Figure 53. Periodic drawing 45; Christmas 1941. "Heaven and Hell."

15. "Heaven and Hell"

Interlocking motifs depicting opposites is a device frequently used by Escher to portray the inability to recognize one without the other. "Heaven and Hell" is such a design (Figure 53). (The print *Encounter* [Figure 14] interlocks a pessimist and an optimist.) Although the periodic design was never incorporated in this form into a print, Escher produced a version of "Heaven and Hell" in *Circle Limit IV*, which is a hyperbolic tessellation. He also used the periodic design as the basis for covering a sphere with a carved version of interlocked angels and devils. (If the periodic design is wrapped around a cube, as we have done with the cube of Model 4, the projection of the cube onto a sphere surrounding it is exactly Escher's carved "Heaven and Hell" sphere.)

To cover the kaleidocycle, wingtips of angels and devils are joined to form the outline of right triangles contained in a square; these triangles are the faces of the kaleidocycle. With each turn of the kaleidocycle the angels and devils change their direction of rotation about the center point of the model—rotating clockwise, then counterclockwise.

16. Lizards

The print *Division* (Figure 54) is the nearest Escher ever came to producing a finished graphic work containing only a periodic design. The print is not a periodic design, however; you can find many deviations from his sketchbook page, which contains the true periodic design (Figure 55).

To cover a kaleidocycle with this design, we form a square grid by joining the centers of four-fold rotation (where heads of four lizards meet), and then bisect these squares into isosceles triangles. The outlined

square containing eight triangles (Figure 55) is the view you will see looking at the completed model from above.

Coloring the periodic design is an interesting exercise. Escher produced two distinct colorings. One uses just two colors (Figure 16); the one shown here uses four colors. From a distance his four-color design appears to be interlocked circles of different colors. We have map-colored our decorated model with a rearrangement of Escher's four colors. Each turn of the kaleidocycle brings a different coloration into view.

Figure 55. Periodic drawing 118; IV 1963. Lizards (four-color variation of design in Figure 16).

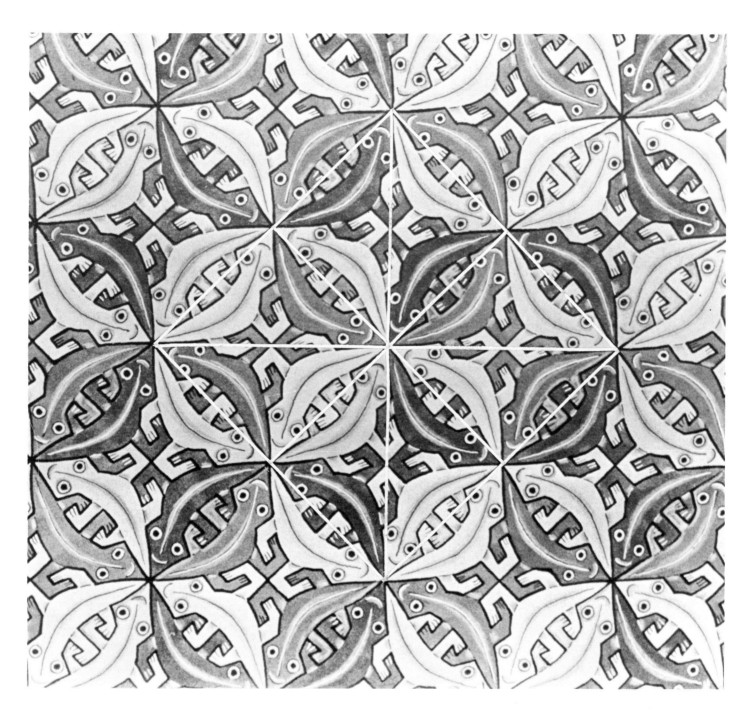

TWISTED KALEIDOCYCLE

17. Encounter

The interlocking design (Figure 19) from which emerge the pessimist and optimist in the print *Encounter* (Figure 14) cannot be adapted to a symmetric kaleidocycle; however, it easily wraps around the surface of a twisted kaleidocycle.

The lattice of points which underlies this periodic design is one of rectangles (to see this, find all repetitions of a chosen point in the pattern— for instance, the tip of the nose of a pessimist facing right). To cover

the twisted model, a slanted grid of triangles was superimposed on the periodic design so that top and bottom edges would match and right and left edges would match. The dimensions of the rectangles in the lattice of the periodic design dictated the edge length of the triangles and the steepness of slant in the flat pattern for the model.

As you turn this jagged ring, the interlocked figures will tumble in an endless cyclic procession.

Sources for More Information

Beard, Col. R.S., *Patterns in Space*, Creative Publications, Palo Alto, California, 1973. Many two- and three-dimensional mathematical designs and constructions. Two rotating rings of tetrahedra are described.

Coxeter, H.S.M., *Introduction to Geometry*, Second Edition, John Wiley & Sons, New York, 1969. Covers the wide range of geometries. College level. (Through correspondence with Coxeter, Escher learned the mathematical rules which govern hyperbolic tessellations; *Circle Limit III* is an example.)

Cundy, H.N. and Rollett, A.P., *Mathematical Models*, Third Edition, Tarquin Publications, 1981. Detailed information on the Platonic and Archimedean solids, and many other beautiful geometric models.

Ernst, Bruno, *The Magic Mirror of M.C. Escher*, Random House, New York, 1976; paperback edition, Ballantine Books, New York, 1977. Discusses all aspects of Escher's work, including Escher's use of mathematics to obtain many of his surprising effects.

Escher, M.C., *The Graphic Work of M.C. Escher*, Ballantine Books, New York, 1971. A collection of Escher's work with notes by the artist.

Escher M.C. *His Life and Complete Graphic Works* Harry Abrams, New York and Thames and Hudson Ltd. London 1982.

Jenkins, Gerald and Wild, Anne. *Mathematical Curiosities*. Three books of interesting and curious models of a mathematical nature to cut out and make, including kaleidocycles. *Make Shapes*. Three books of mathematical models to cut out, color and make. Tarquin Publications 1978-82.

Locher, J.L. (ed.), *The World of M.C. Escher*, Harry N. Abrams, Inc., New York, 1971. A collection of Escher's work with essays concerning various aspects of it.

MacGillavry, Caroline, *Fantasy and Symmetry. The Periodic Drawings of M.C. Escher*, Harry N. Abrams, Inc., New York, 1976. Reprint of 1965 edition, published for International Union of Crystallography by A. Oosthoek's Uitgeversmaatschappij, Utrecht, under title: *Symmetry Aspects of M.C. Escher's Periodic Drawings*. Contains 41 of Escher's periodic tilings. Originally written to interest beginning crystallography students in the laws which underlie repeating designs and their colorings.

O'Daffer, P.G. and Clemens, S.R., *Geometry: An Investigative Approach*, Addison-Wesley, Menlo Park, California, 1976. Includes wide range of elementary information on Platonic solids, transformation geometry, and repeating designs, with Escher's work used frequently for illustration.

Weninger, Magnus J., *Polyhedron Models*, Cambridge University Press, Cambridge, 1971. Construction of Platonic, Archimedean, and other symmetric geometric solids.

Instructions for Assembling the Models

FOR ALL MODELS

1 To make a model of your choice, detach the whole page from the book.
2 Turn over and score along all the fold lines on the back using a ruler and a ball-point pen.
3 Cut out precisely.
4 Follow the detailed instructions below for each model. Fold along the scored lines in the direction indicated, either face to face referring to the patterns, or back to back. The photographs which follow show all plain faces for clarity, but of course the Escher patterns are on the outside!
5 Before gluing, fold up each model as directed to see that you understand its proper assembly. The printed comments "Glue 1", "Glue 2" etc. will help with the assembly of the kaleidocycles.
6 Use a quick drying glue suitable for paper, such as a clear cement or a white latex type glue. Do not use an 'instant glue' as you may need time to match the pattern, nor any glue which leaves dirty marks.
7 Glue one tab at a time, according to the instructions, until the model is complete. Each tab glues to the inside of each model, so that each edge has a perfectly matched continuous design.

ASSEMBLING THE SOLIDS (MODELS 1-6)

Fold the pattern back to back along all scored lines, including those which adjoin tabs. Fold up each model as indicated in the diagrams below and then glue each tab to the inside of the adjoining face. In every case carefully match the design at the joined edges. Rub the seams which have been glued in order to obtain a secure bond.

1. Tetrahedron

Fold up and glue tabs to inside of edges as shown in Figure 56. Glue remaining edge.

Figure 56. Tetrahedron assembly.

2. Octahedron

Join two halves of model, gluing tab A to matching edge to form flat pattern shown in Figure 57. Fold up and glue tabs to inside of edges as shown; this forms two hinged pyramids. Join the matching edges of the pyramids.

3. Icosahedron

Join two halves of model, gluing tab A to matching edge to form flat pattern shown in Figure 58. Fold up and glue tabs to inside of edges as shown; this forms two joined "caps." Join the matching edges of the caps.

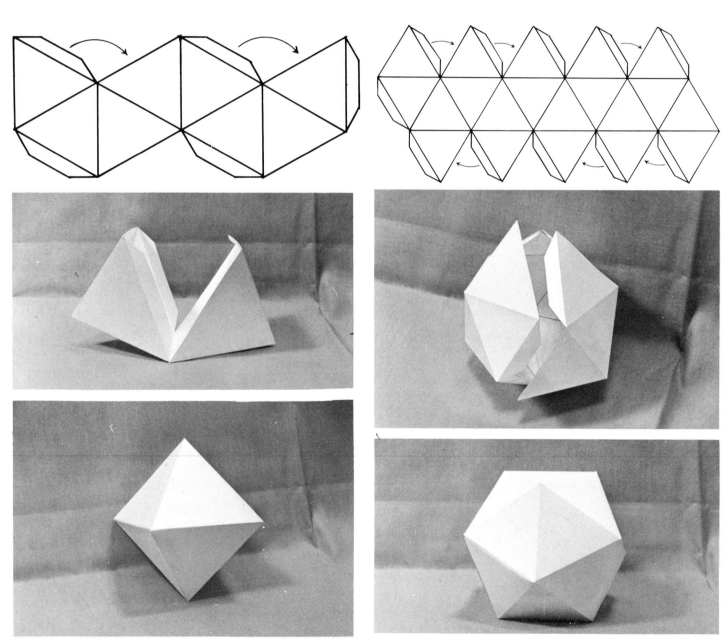

Figure 57. Octahedron assembly.

Figure 58. Icosahedron assembly.

4. Cube

Join two halves of model, gluing tab A to matching edge to form flat pattern shown in Figure 59. Fold up and glue tabs to inside of edges as shown. Now complete by joining edges of the box.

5. Dodecahedron

Join two halves of model, gluing tab A to matching edge to form flat pattern shown in Figure 60. Fold up and glue tabs to inside of edges of the "petals" as shown; this forms two hinged "caps." Join the matching edges of the caps.

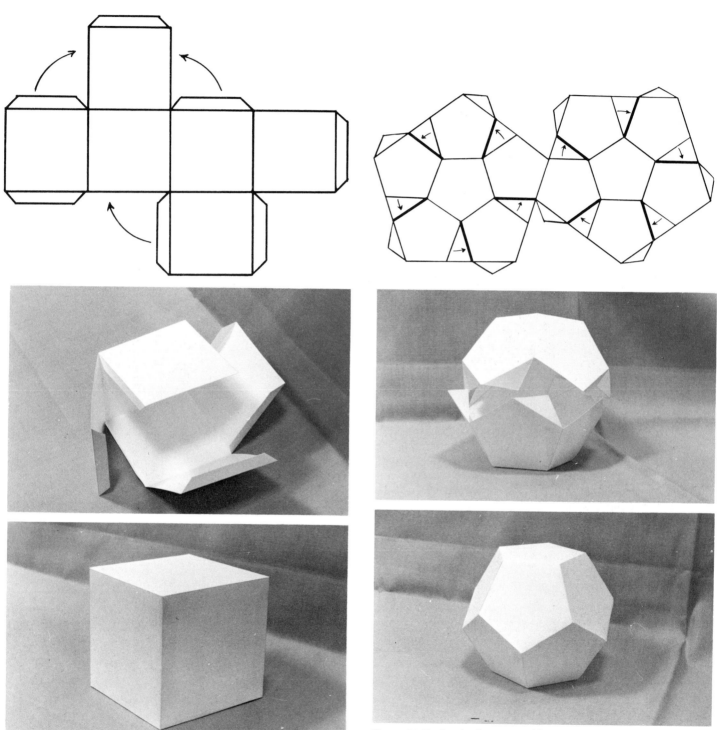

Figure 60. Dodecahedron assembly.

Figure 59. Cube assembly.

6. Cuboctahedron

Fold up and glue tabs to inside of edges as shown in Figure 61; this forms two hinged "caps." Join matching edges of the caps, always joining a triangle to a square.

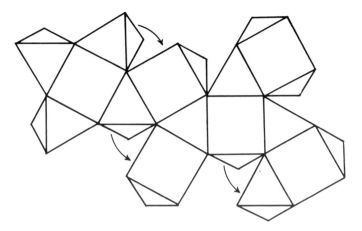

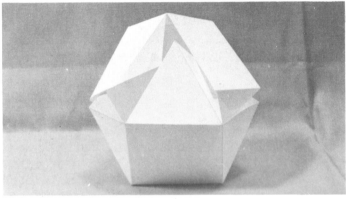

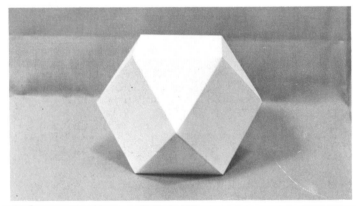

Figure 61. Cuboctahedron assembly.

Figure 62 shows grids of the three types of kaleidocycles. The two halves of the twisted kaleidocycle should be joined, gluing tab A to matching edge. Thick lines on these diagrams are *vertical*; other lines are *diagonal*.

All patterns are folded on the scored lines as follows: Fold *face to face* on all *vertical* scored lines, including those which adjoin tabs. Fold *back to back* on all *diagonal* scored lines. The folded pattern will begin to naturally curl into shape.

Gently cup the pattern in your hands so that the bottom triangles come around to meet the triangular blank white tabs at the top of the pattern. Put glue on these white tabs and glue the triangles to these tabs. Match designs exactly and make sure that all seams are completely sealed. You now have a chain of linked tetrahedra. Let glue dry before proceeding to the next step.

Hold the chain of tetrahedra in both hands and bring its ends together to form a ring. You may need to turn the ring to accomplish this. The double tab on one end will be fitted inside the slot at the other end of this ring (For the twisted model, the ring must be twisted to accomplish this.)

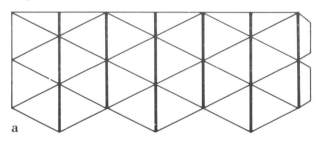

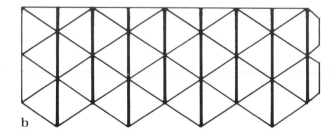

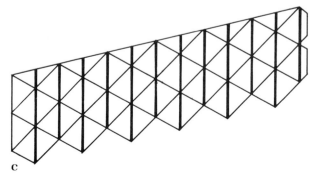

Figure 62. (a) Hexagonal kaleidocycle grid. (b) Square kaleidocycle grid. (c) Twisted kaleidocycle grid.

Put glue on each of the outer sides of the double tab and slide it into the open slot at the other end of the ring. Adjust its position for a perfect match of design. Turn the ring so that you can apply pressure with your finger to seal the seam. Wipe off excess glue and let the seam set for several seconds, holding the model in position so that the seam does not separate. Now gently turn the model over and rotate it slightly to bring into view the seam on the opposite side. Match the design and seal this seam, again holding the model so that the seam does not separate.

When these seams have "set," *let the model dry thoroughly* (preferably overnight) before attempting to rotate it. When dry, it can be rotated in a continuous cycle of motion by pushing the points of the tetrahedra through the center hole.

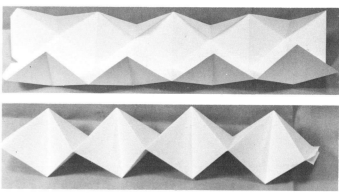

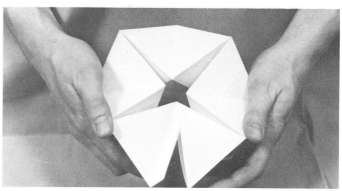

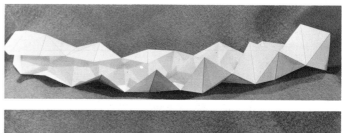

(b) Square kaleidocycle assembly.

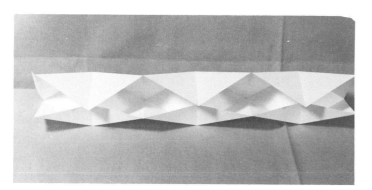

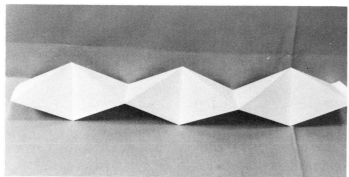

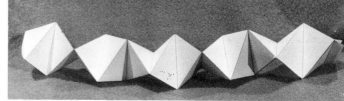

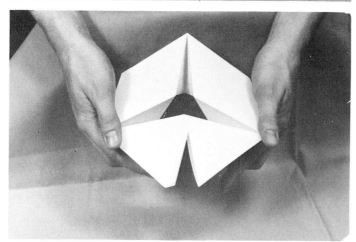

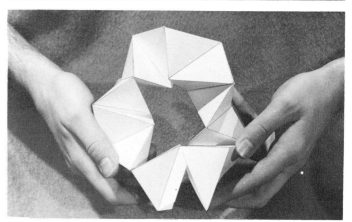

Figure 63. (a) Hexagonal kaleidocycle assembly.

(c) Twisted kaleidocycle assembly.

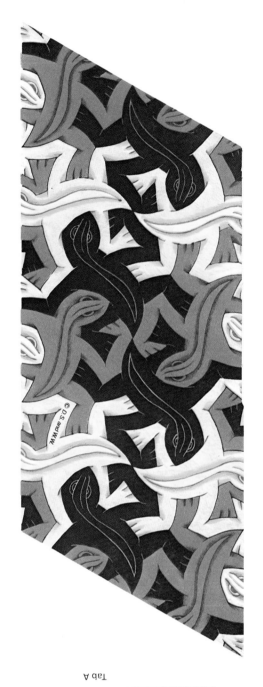

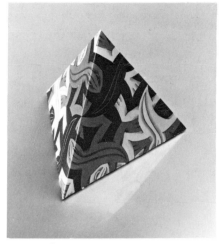

Reptiles
MODEL NO 1 TETRAHEDRON

Periodic drawing 56; XI 1942.
Reptiles.

This curious design has no complete
reptile on any face of the tetrahedron,
but every reptile becomes whole as it
creeps across the edges and on to the
other faces.

Three worlds
MODEL NO 2 OCTAHEDRON

From a detailed drawing and design for
an ivory sphere.

Escher provided the drawings for the
Japanese craftsman Masatoshi to make
an ivory sphere. Each face of the
octahedron model contains half of each
of the three motifs, a bat, a lizard and a
fish, representing three different, but
inter-related worlds.

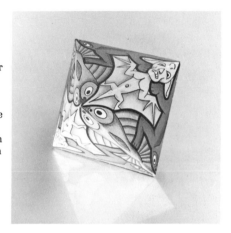

Tab A

Edge A

45

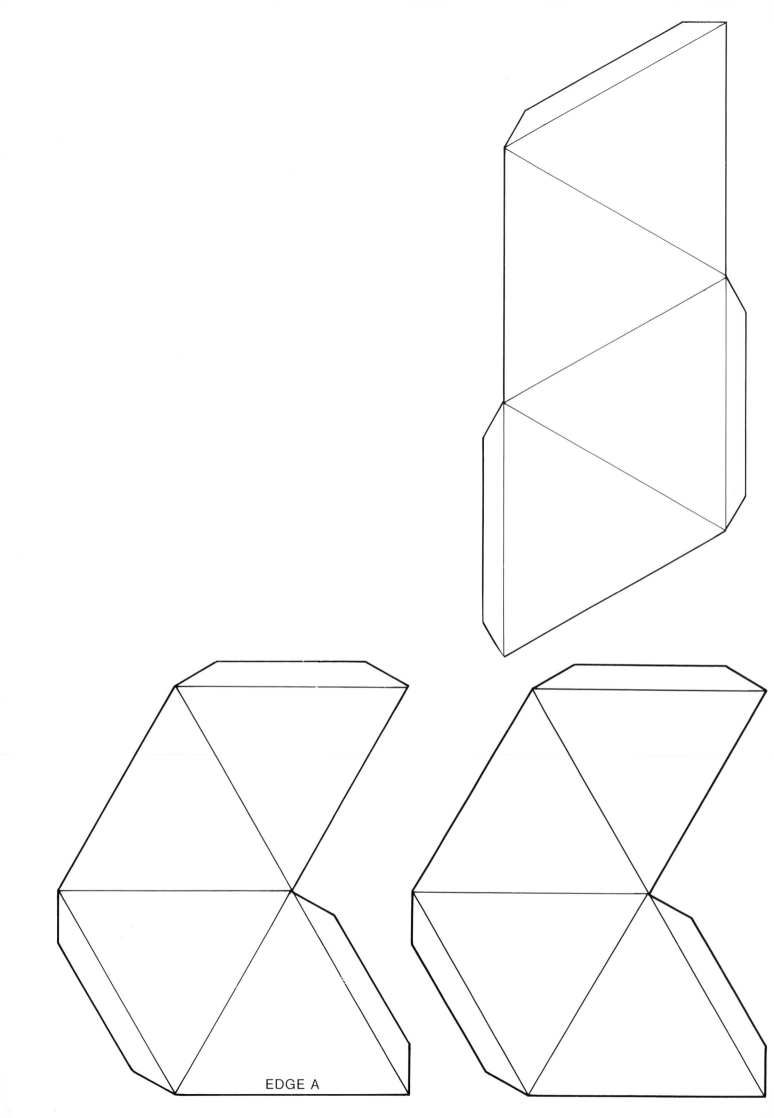

EDGE A

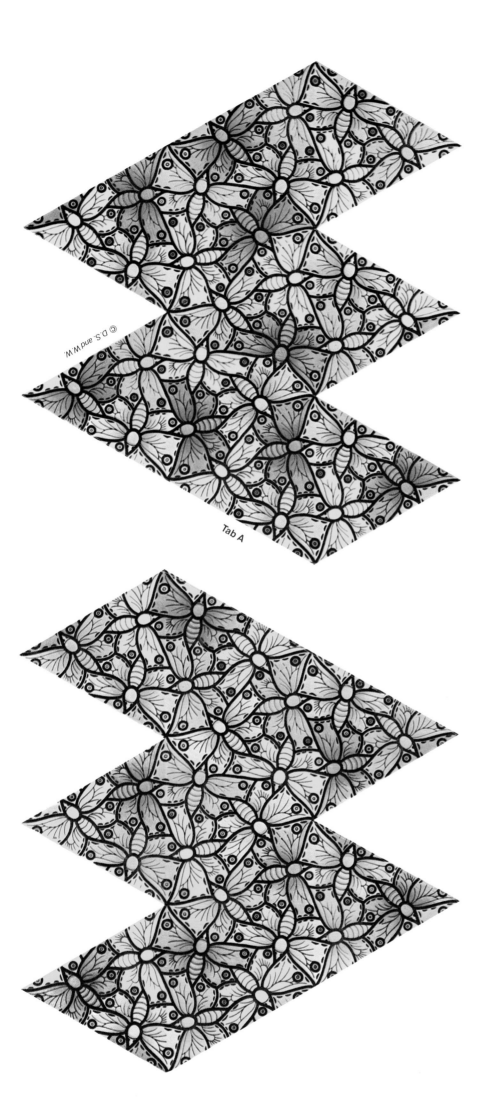

Tab A

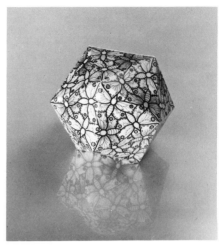

Butterflies
MODEL NO 3 ICOSAHEDRON

Periodic drawing 70; III 1948.
Butterflies.

Sixty butterflies cover the surface of this
icosahedron with every face identical
except for the coloration. On a flat
surface three colors are sufficient for
this design, but a three-dimensional
model needs four.

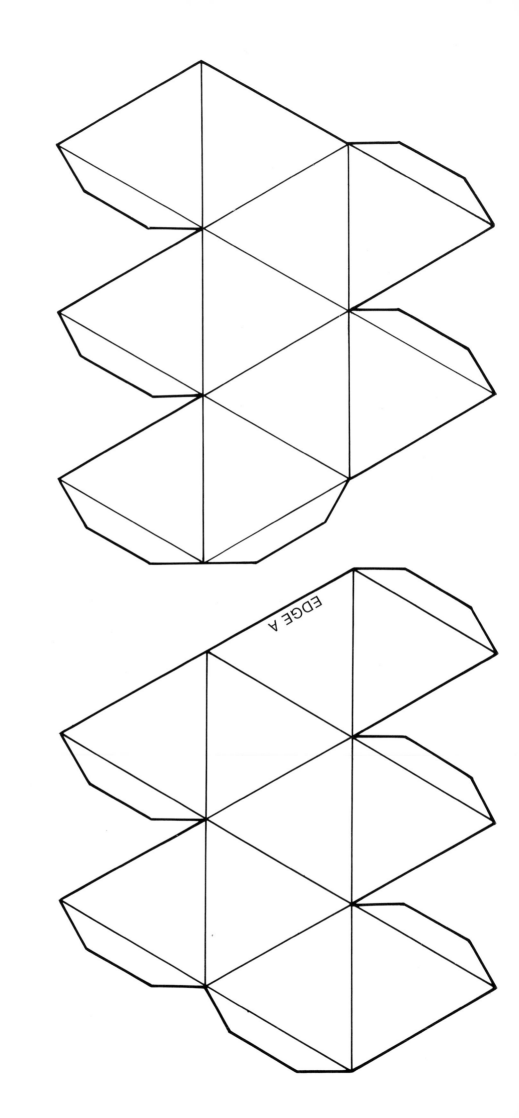

EDGE A

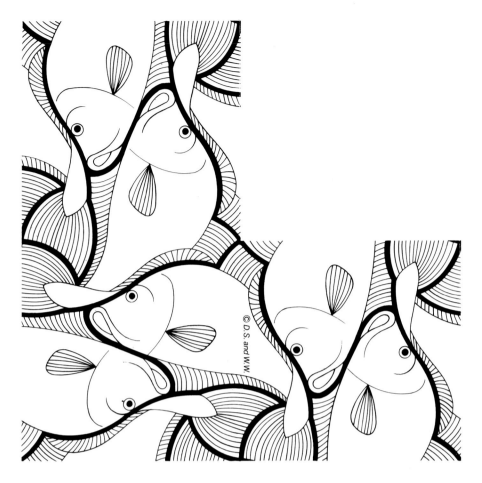

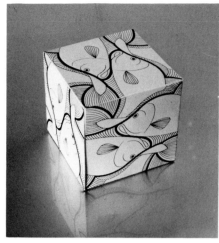

Fish
MODEL NO 4 CUBE

Periodic drawing 20; III 1938.
Fish.

This design is closely related to Escher's
"sphere with fish". Twelve fish swim in
a symmetrical way across the faces of
the cube and pose an interesting coloring
puzzle.

Tab A

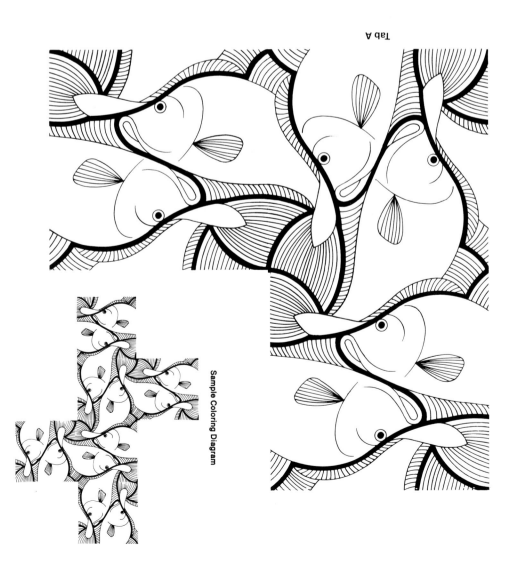

Sample Coloring Diagram

49

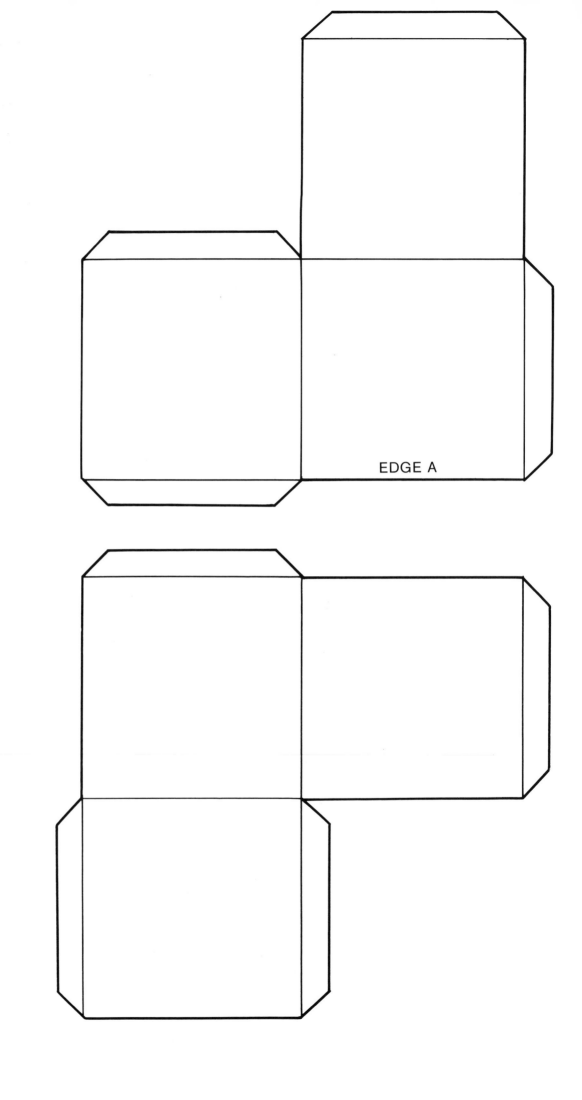

EDGE A

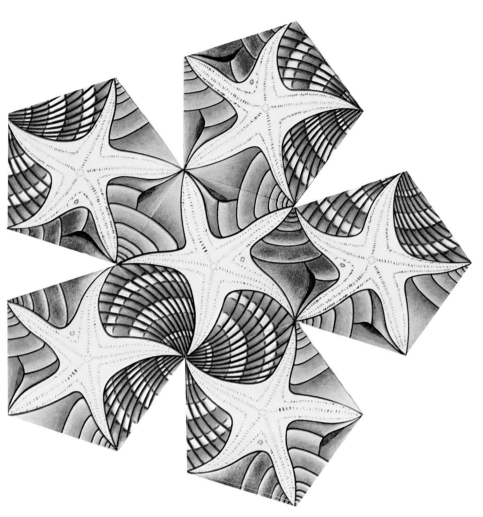

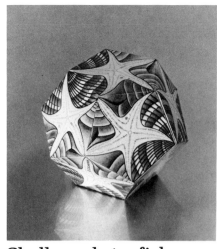

Shells and starfish
MODEL NO 5 DODECAHEDRON

Periodic drawing 42; VIII 1941.
Shells and starfish.

One of Escher's favorite geometric
designs was a tessellation of irregular
pentagons, and what better motif for a
five-sided figure than a starfish!
Transformed into regular pentagons for
this dodecahedron model, a starfish
decorates every face, cunningly
surrounded by three kinds of shell.

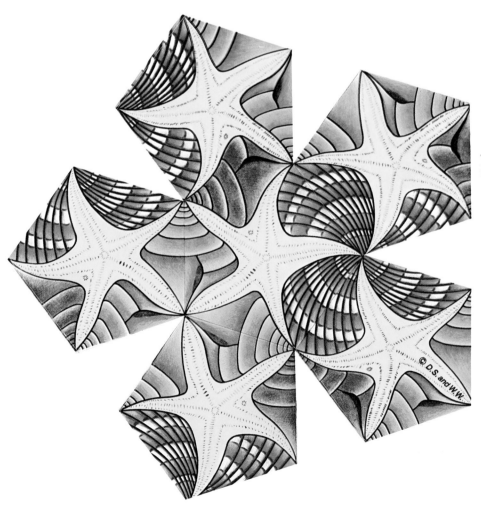

Tab A

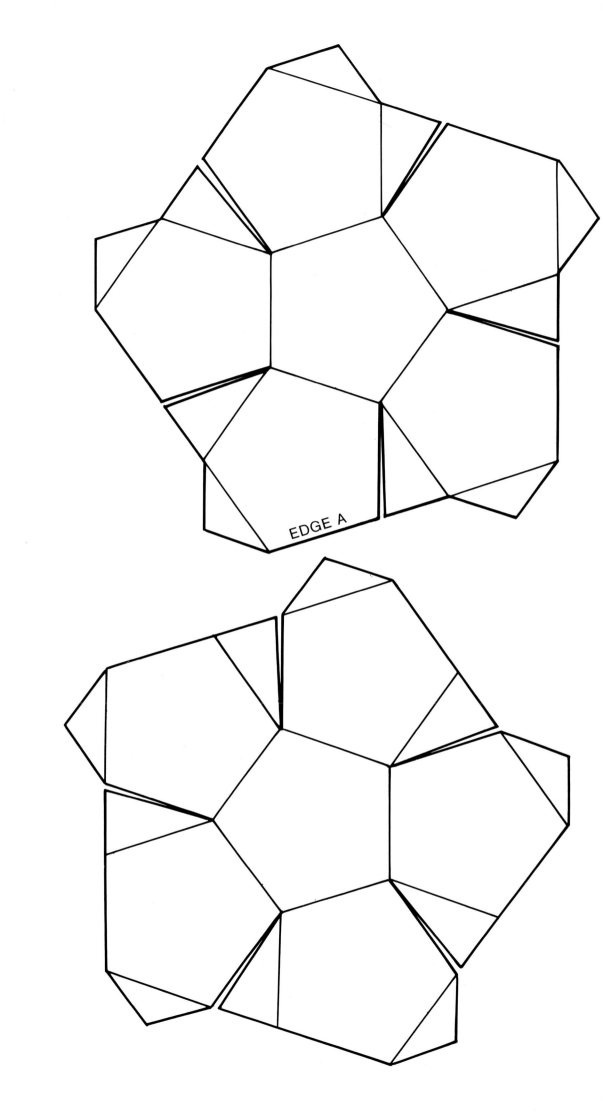

EDGE A

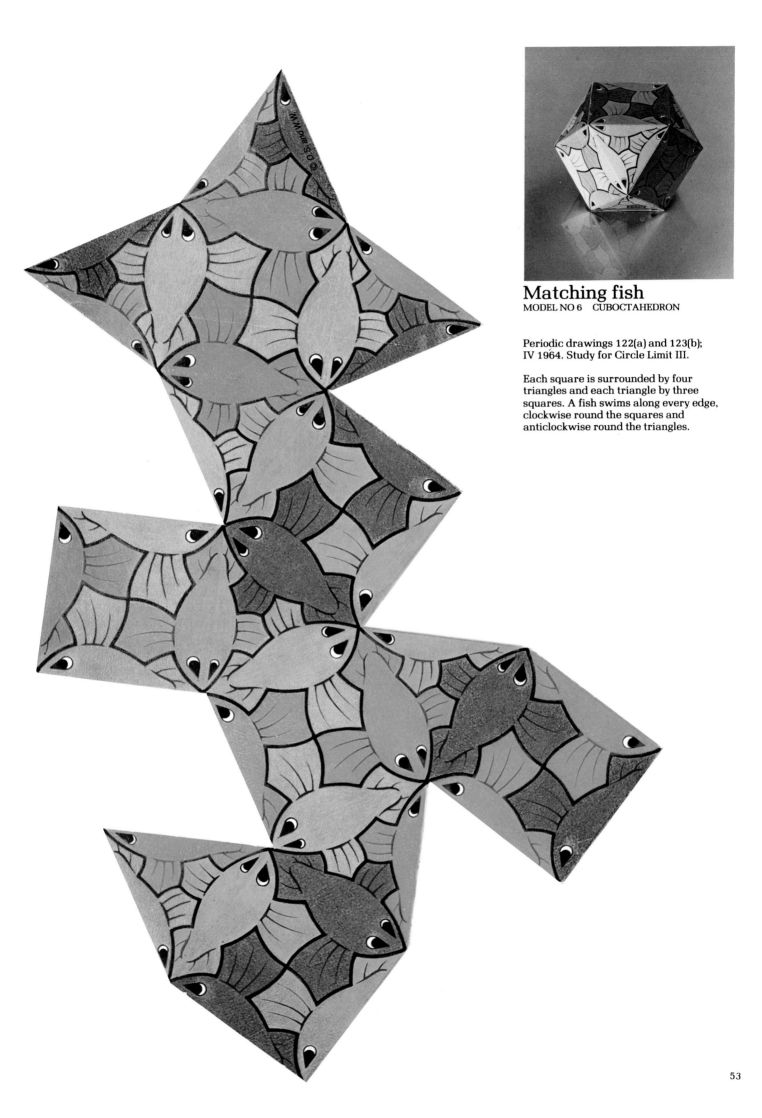

Matching fish
MODEL NO 6 CUBOCTAHEDRON

Periodic drawings 122(a) and 123(b);
IV 1964. Study for Circle Limit III.

Each square is surrounded by four
triangles and each triangle by three
squares. A fish swims along every edge,
clockwise round the squares and
anticlockwise round the triangles.

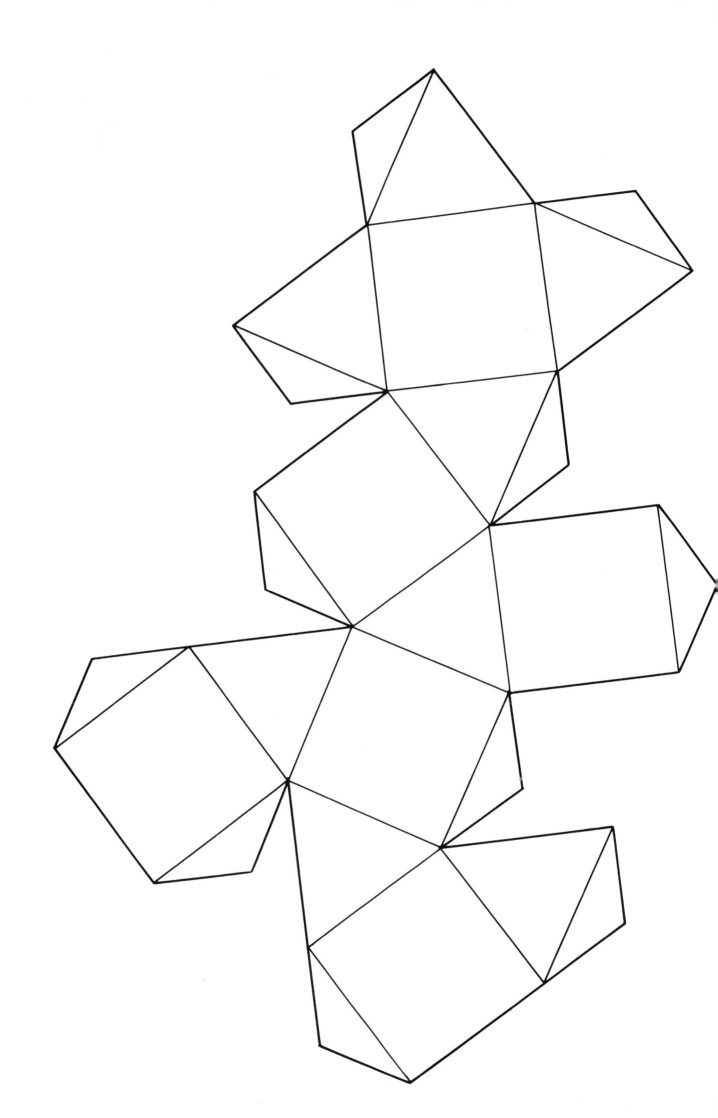

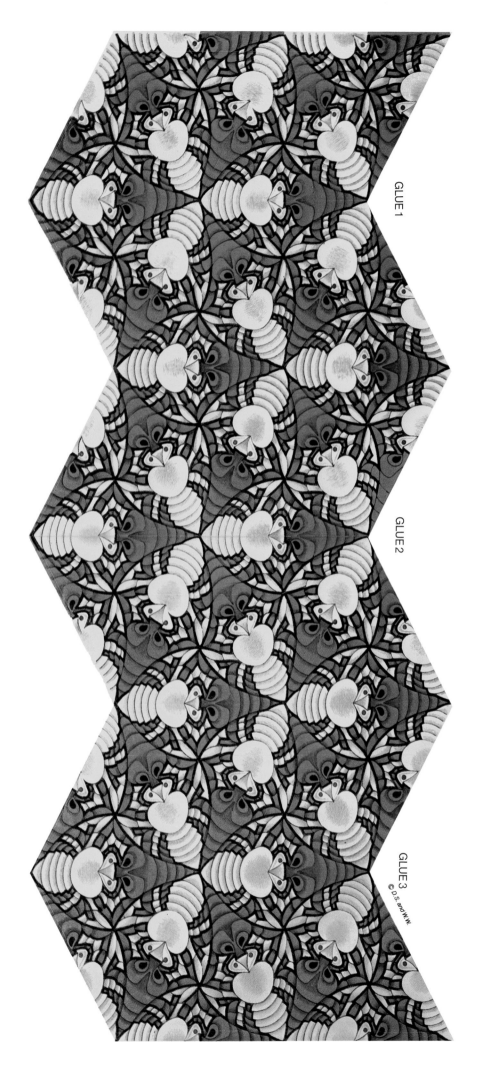

GLUE 1

GLUE 2

GLUE 3

© D.S and W.W.

Bugs
MODEL NO 7
HEXAGONAL KALEIDOCYCLE

Periodic drawing 54; X 1942.
Bugs.

Remarkably enough, only two colors are
needed for this intricate interlocking
pattern, even when it is made into a
three-dimensional model. As the
kaleidocycle turns, the bugs form and
reform in endless procession.

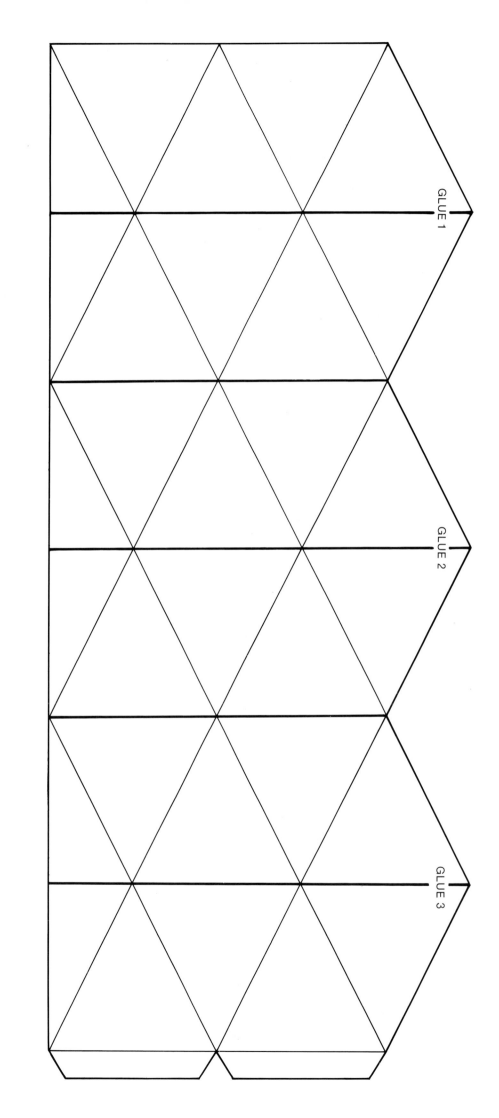

GLUE 1

GLUE 2

GLUE 3

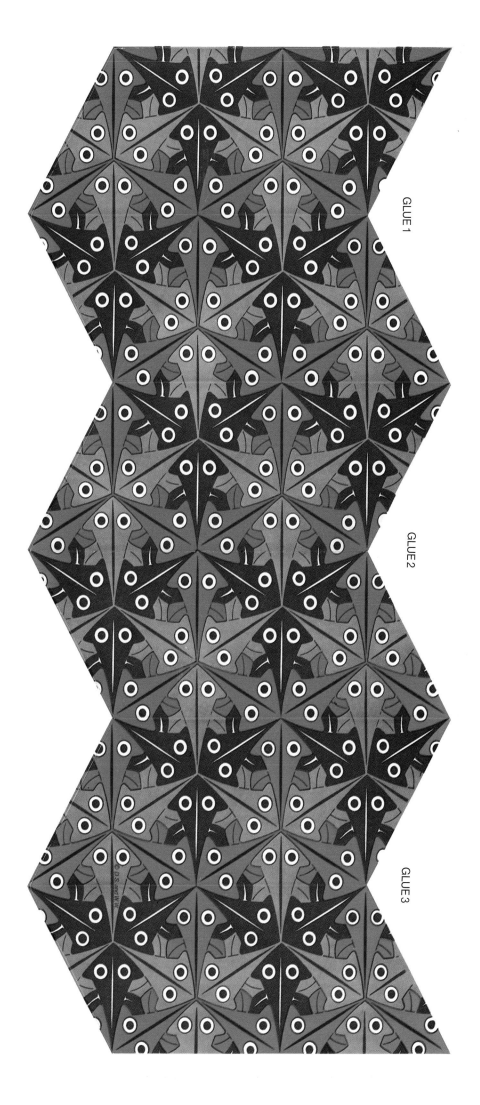

GLUE 1

GLUE 2

GLUE 3

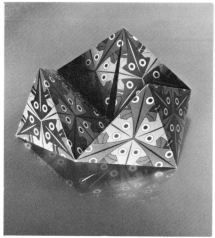

Fish
MODEL NO 8
HEXAGONAL KALEIDOCYCLE

Periodic drawing 103; IV 1959.
Fish.

Red, black and grey fish motifs meet in
threes by the head and by the tail. It is
mysterious that the grey fish never find
their way to the center of the
kaleidocycle, leaving the red to dominate
it with the black in support.

57

GLUE 1

GLUE 2

GLUE 3

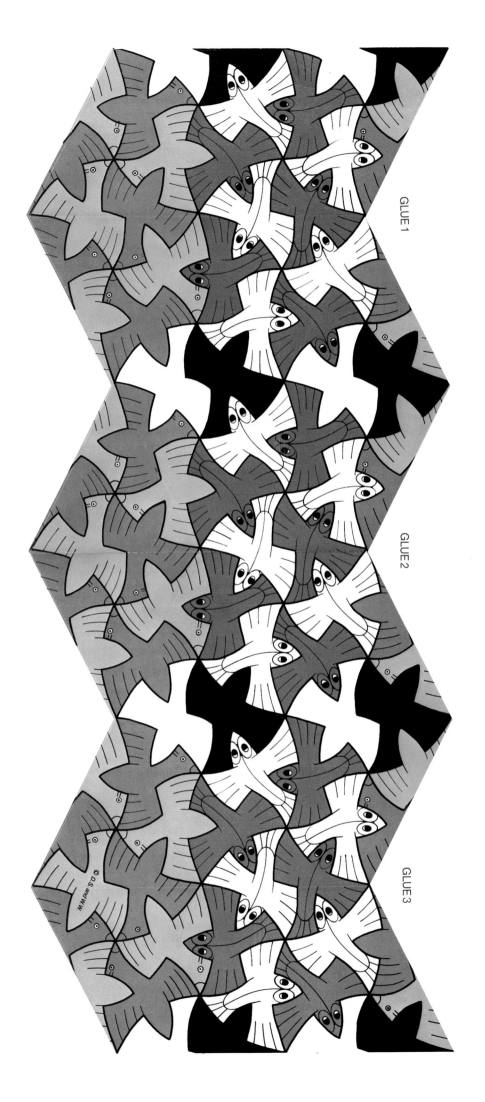

GLUE 1

GLUE 2

GLUE 3

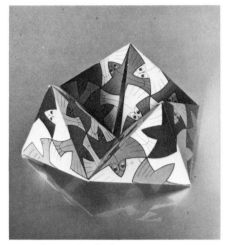

Bird or fish?
MODEL NO 9 HEXAGONAL
KALEIDOCYCLE

Periodic drawing 44; XII 1941. Birds.
Woodcut print from Regelmatige
Vlakverdelung 1958.

The same outline can suggest a bird or a
fish and this design sees the
metamorphosis of one into the other as
the kaleidocycle turns.

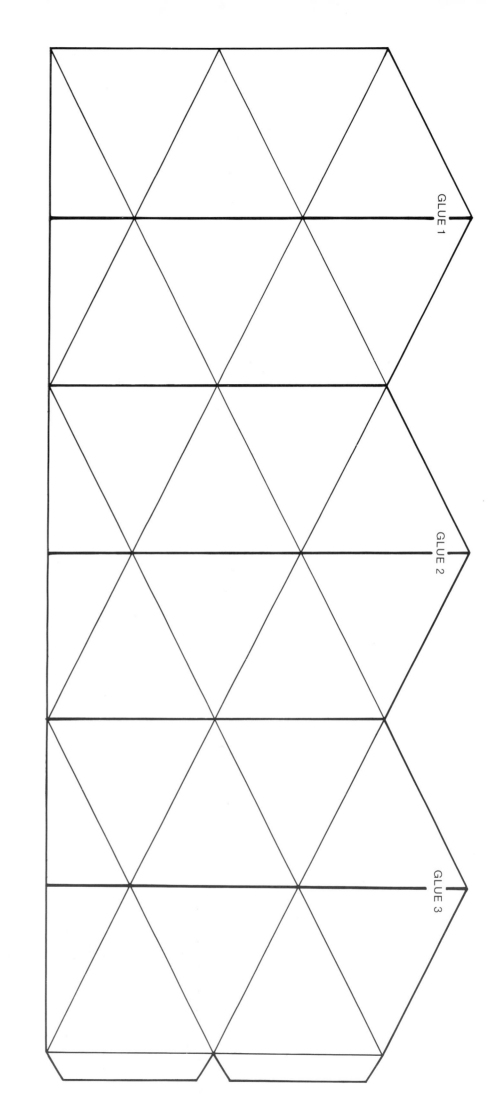

GLUE 1

GLUE 2

GLUE 3

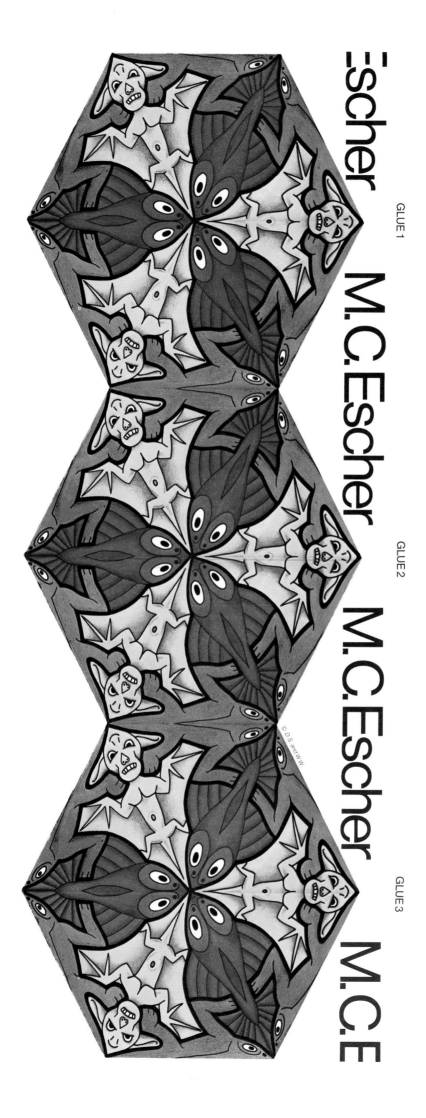

GLUE 1

GLUE 2

GLUE 3

Escher

M.C.Escher

M.C.Escher

M.C.E

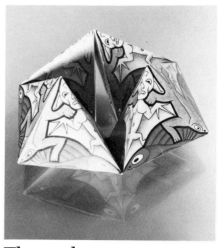

Three elements
MODEL NO 10
HEXAGONAL KALEIDOCYCLE

Periodic drawing 85; IV 1952
Three elements.

Bats, lizards and fish represent the three elements of air, land and water and three of each in sequence meet at the center of the turning kaleidocycle.

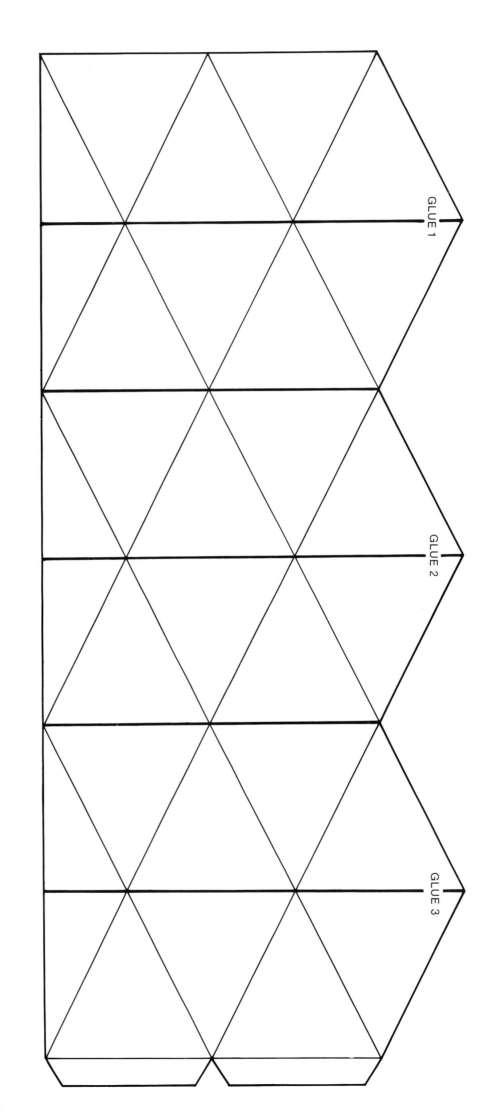

GLUE 1

GLUE 2

GLUE 3

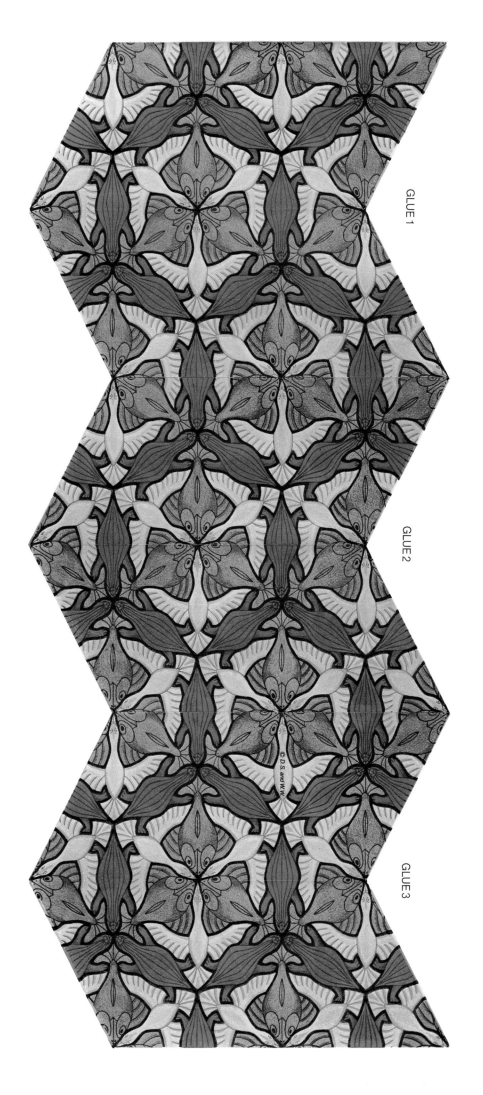

GLUE 1

GLUE 2

GLUE 3

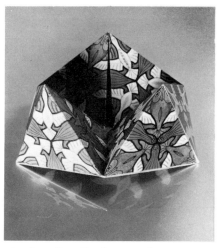

Fish, duck, lizard
MODEL NO 11
HEXAGONAL KALEIDOCYCLE

Periodic drawing 69; III 1946.
Fish, duck, lizard (first version of
"Three Elements").

Three of each of two of the creatures
meet at every head and every tail in
intriguing combination.

GLUE 1

GLUE 2

GLUE 3

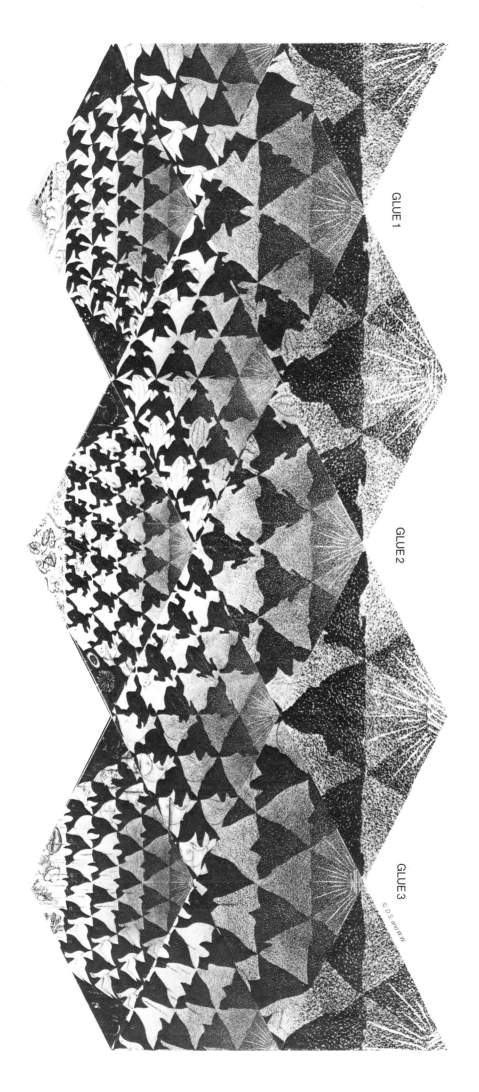

GLUE 1

GLUE 2

GLUE 3

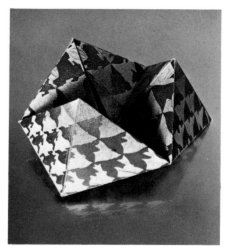

Verbum
MODEL NO 12
HEXAGONAL KALEIDOCYCLE

Periodic drawing 50; VII 1942.
Study for "Verbum".

Two kinds of transformation are taking place. From the center outwards, vague amorphous shapes gradually evolve into recognisable creatures, while round the rim they metamorphose – bird into fish into frog into bird and so on – once again expressing the cycle of the three elements air, water and land.

GLUE 1

GLUE 2

GLUE 3

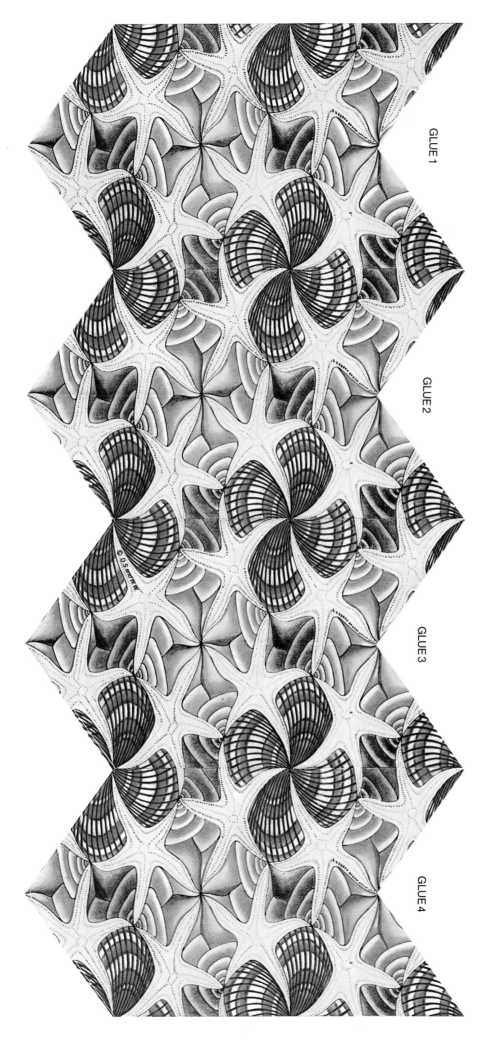

GLUE 1

GLUE 2

GLUE 3

GLUE 4

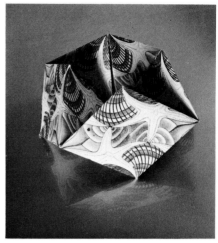

Shells and starfish
MODEL NO 13 SQUARE KALEIDOCYCLE

Periodic drawing 42; VIII 1941.
Shells and starfish.

Four shells of two different kinds take it
in turns to meet at the center of the
kaleidocycle as it rotates while starfish
and other shells dance in attendance.

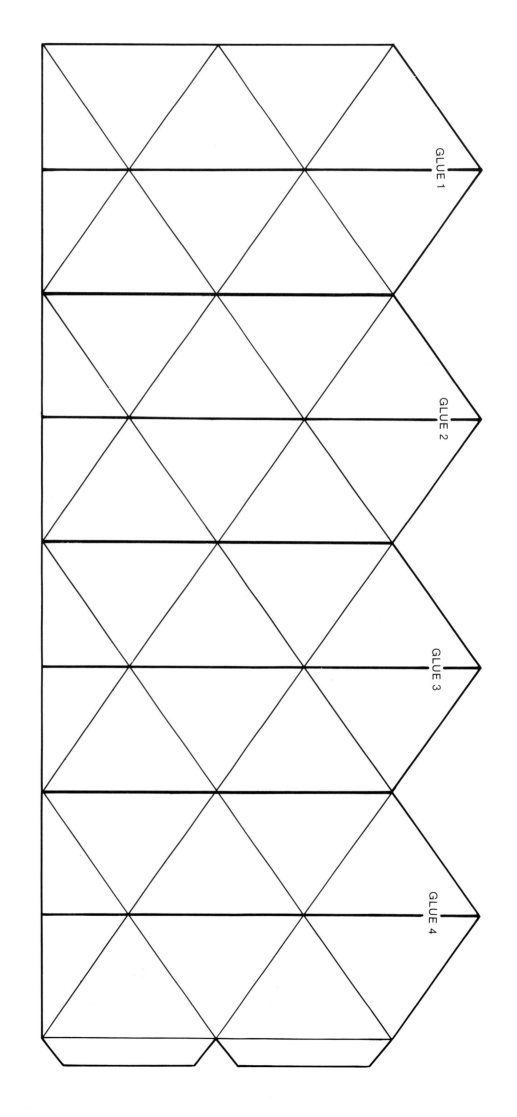

GLUE 1

GLUE 2

GLUE 3

GLUE 4

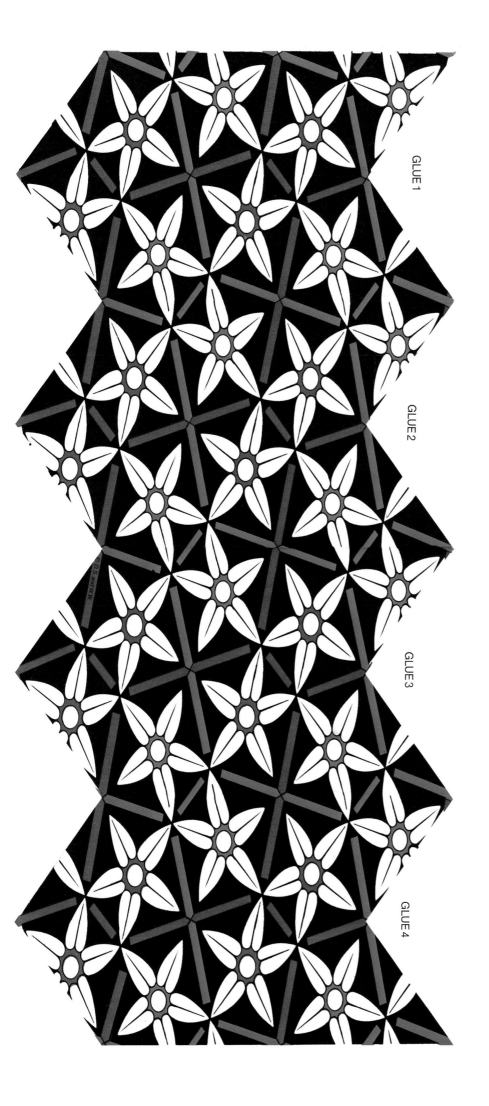

GLUE 1

GLUE 2

GLUE 3

GLUE 4

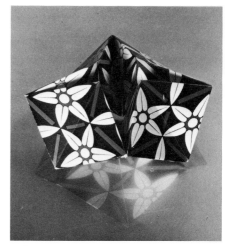

Flowers
MODEL NO 14 SQUARE KALEIDOCYCLE

Periodic drawing 132; XII 1967.
Flowers.

Irregular pentagons which surround the
flowers with some sides red and some
sides blue are miraculously transformed
into alternate red and blue as the
kaleidocycle turns.

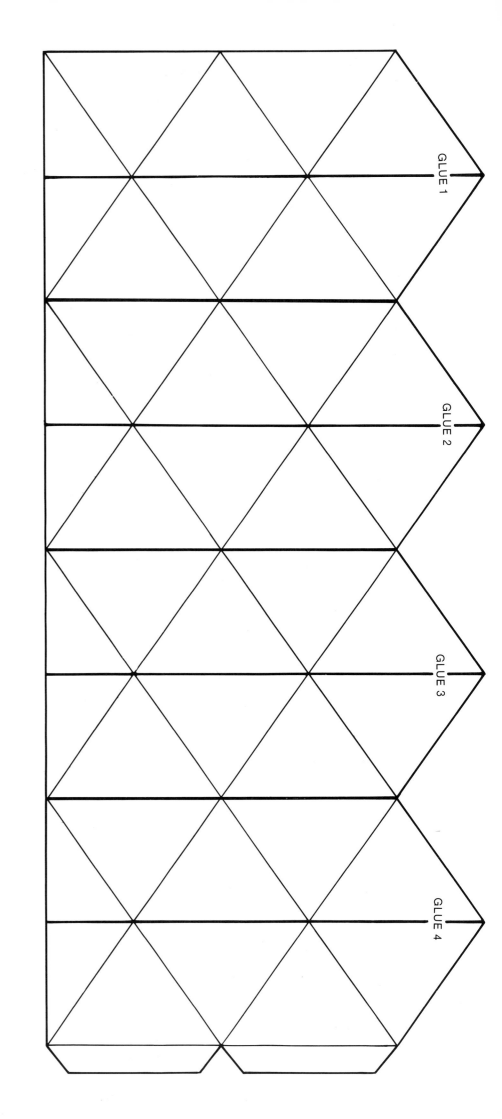

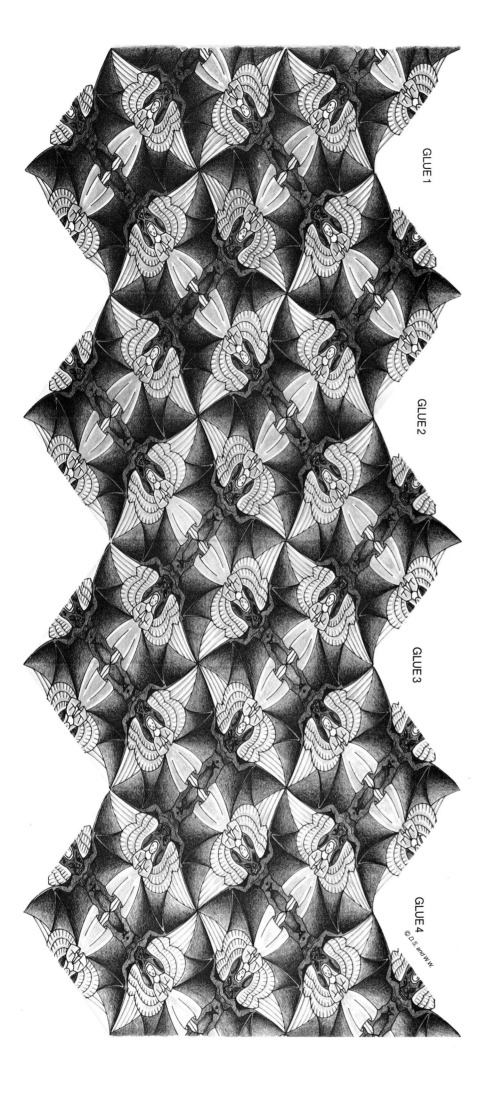

GLUE 1

GLUE 2

GLUE 3

GLUE 4

© D.S. and W.W.

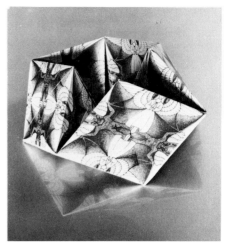

Heaven and hell
MODEL NO 15 SQUARE KALEIDOCYCLE

Periodic drawing 45; Christmas 1941.
Heaven and Hell.

Interlocking motifs of angels and devils
depict in vivid graphic form the idea of
opposites and our inability to recognise
one without the other.

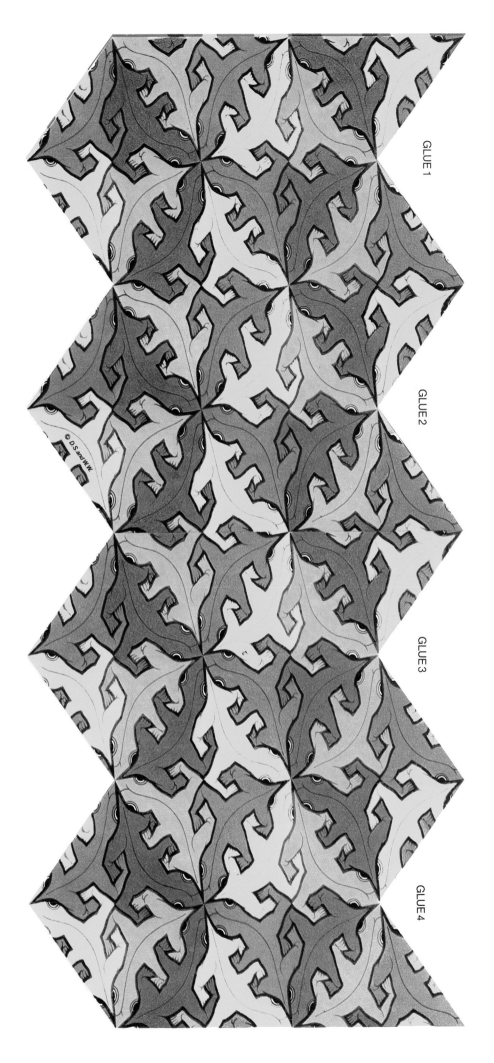

GLUE 1

GLUE 2

© D.S. and W.W.

GLUE 3

GLUE 4

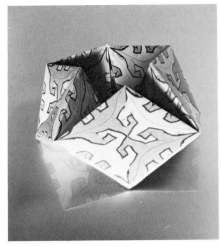

Lizards
MODEL NO 16 SQUARE KALEIDOCYCLE

Periodic drawing 118; IV 1963.
Lizards.

On the flat surface four lizards meet
head to head and with them four more
tail to tail. Each color is represented
twice. However, folding the same pattern
into a kaleidocycle magically transforms
it into four heads of one color and four
tails of another – and they change when
the kaleidocycle turns!

GLUE 1

GLUE 2

GLUE 3

GLUE 4

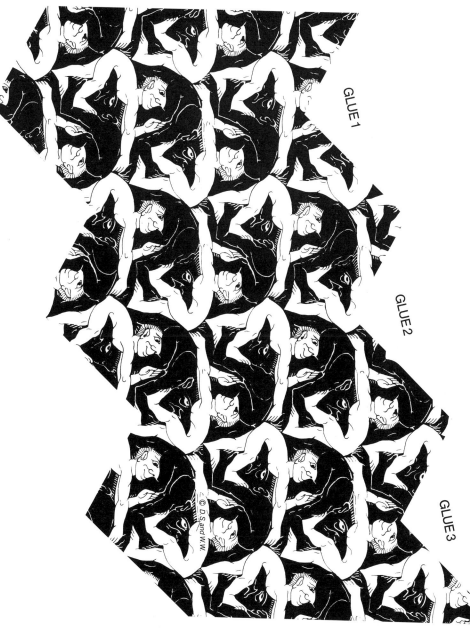

GLUE 1

GLUE 2

GLUE 3

© D.S. and W.W.

Tab A Tab A

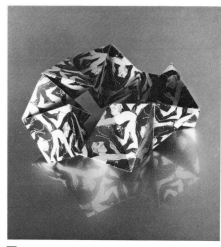

Encounter
MODEL NO 17 TWISTED KALEIDOCYCLE

Periodic drawing 63; II 1944.
Study for "Encounter".

The interlocked white figures of the
optimists and the black figures of the
pessimists tumble endlessly through the
centre of the jagged ring as it turns.

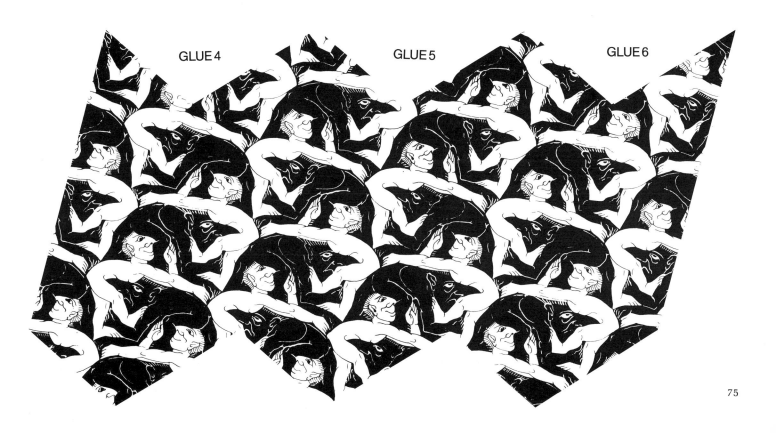

GLUE 4 GLUE 5 GLUE 6

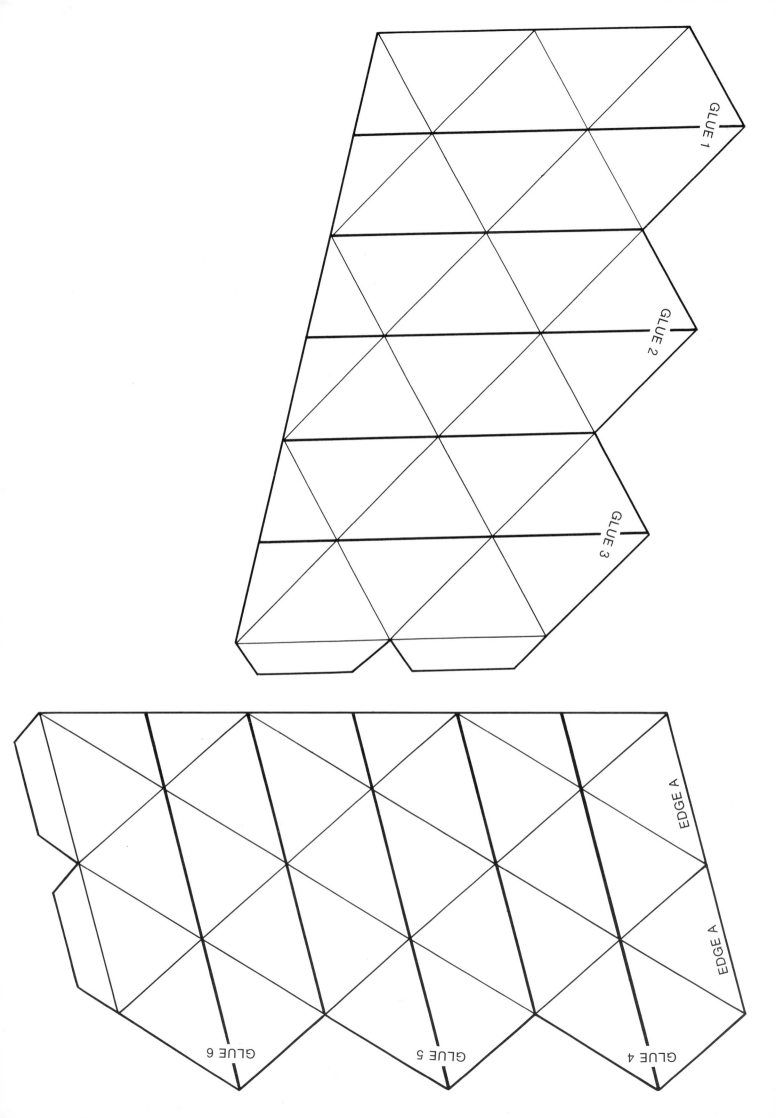

GLUE 1

GLUE 2

GLUE 3

EDGE A

EDGE A

GLUE 6

GLUE 5

GLUE 4